Life Drawing

A COMPLETE COURSE

E. L. Koller

DOVER PUBLICATIONS, INC.
MINEOLA, NEW YORK

Bibliographical Note

This Dover edition, first published in 2008, is a reprint composed of the sections "The Human Figure," "The Figure in Repose," and "The Figure in Action" from *Still Life and Figure Drawing,* originally published by the International Textbook Company, Scranton, Pennsylvania, in 1915. The three color plates that appeared in the section "The Figure in Action" in the original edition have been rendered as black and white on pages 197, 198, and 199 of the Dover edition.

Library of Congress Cataloging-in-Publication Data

Koller, E. L. (Edmund Leonard), b. 1877.
 [Still life and figure drawing]
 Life drawing : a complete course / E.L. Koller.
 p. cm.
 Originally published: Still life and figure drawing. Scranton, Pa. :
International Textbook Co., 1915.
 ISBN-13: 978-0-486-46882-2
 ISBN-10: 0-486-46882-8
 1. Figure drawing—Technique. I. Title.

NC765.K65 2008
743.4—dc22

2008029620

Manufactured in the United States of America
Dover Publications, Inc., 31 East 2nd Street, Mineola, N.Y. 11501

Life Drawing

A COMPLETE COURSE

THE HUMAN FIGURE

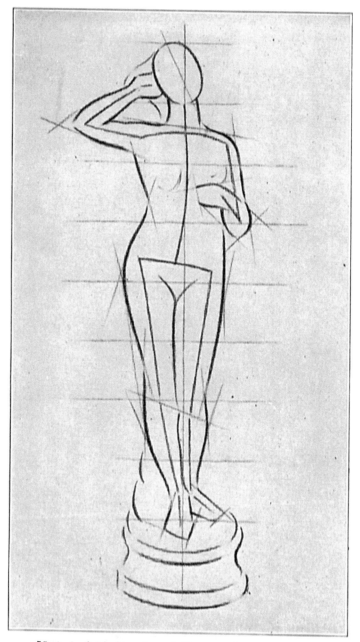

Method of Blocking in, and Proportioning, the Idealized
Classic Figure Eight Heads High. The Living Model of
the Female Figure is Considered as Only Seven Heads High.

THE HUMAN FIGURE

PLACE OF HUMAN FIGURES IN ILLUSTRATING

1. Four Stages in Learning to Draw.—The use of the human figure usually occupies a prominent part in the composition and drawing of pictorial and decorative work. But the human figure is extremely difficult to draw, being composed of so many subtle curves and contours, and such delicate gradations of light and shade in its modeling, that, before these can be drawn and rendered properly, training must be had in drawing more simple forms. For that reason training has been given in line drawing and eye measurement, in model drawing in outline, and in drawing from inanimate models to portray light, shade, and shadow, this preliminary training serving as a series of graded steps leading up to the drawing of the human figure. The next natural and logical step is to draw the human figure, which may be considered the fourth stage in learning to draw.

2. Proper Foundation for Figure Drawing.—Before one can draw the human figure he must be thoroughly familiar with the proportions, measurements, and contours of the human figure as a whole, and of each of its individual parts. To give such a familiarity is the purpose of this subject, which may be considered as a sort of reference book. The information given here must be thoroughly understood, and practice secured in actually sketching such proportions, before the practical work of drawing human figures in various postures and actions can be taken up. In the following subjects the training in figure drawing is extended to include drawing the figure in repose and in action.

Owing to the demand, by a certain class of art students, for a short-cut method of drawing the human figure, unprincipled persons posing as instructors have denied the necessity of a well-laid foundation for drawing the human figure. Their so-called short cuts for teaching the drawing of this, the most complicated of all subjects, however, do not train one to do original work in actually drawing from the living model. They teach only facility in copying the work of others, an accomplishment that is of no practical value to the prospective illustrator.

3. Foundation for Caricaturing and Cartooning.—A careful systematic study of the human figure is absolutely necessary for any one who desires to draw caricatures and cartoons. Many persons, because of the attraction of the pictures in the comic sections of newspapers and in humorous weekly and monthly magazines, acquire a strong desire to do work of this kind. They, therefore, often study the work of their favorite cartoonists thinking that when able to copy this work satisfactorily their training is done. These persons confuse the ability to copy with the ability to originate.

It is impossible to compose and draw cartoons, caricatures, or original pictures of any kind, unless one has had a thorough graded training in drawing, and no one can draw the human figure without a full knowledge of the rules governing its proportions, etc. Caricatures are but drawings of a face or figure with its features exaggerated and cannot be drawn, except from a copy, until the ability to draw the face or figure in its normal proportions has been obtained. This ability is acquired only by a systematic study of figure drawing, facial expression, etc., such as will be given in this and following Sections.

The student is strongly advised against the practice of copying caricatures and cartoons made by professional artists, or making comic drawings in imitation of some cartoonist's individual style. Such a practice will be of absolutely no value in training him to draw the human figure, or in acquiring an individual style.

PROPORTIONS OF HUMAN FIGURE

FRAMEWORK OF FIGURE

4. Application of Principle of Structural Forms.
The transition from drawing inanimate models in outline and
light and shade to drawing the human figure is not, in reality,
an abrupt one. As the curved line is based on the straight line
and can be drawn more easily and accurately if straight con-
struction lines are drawn, and as solids with curved sides and
edges are based on solids with straight sides and edges, so may
the human figure and its individual parts be based on rectilinear
shapes of given proportions. This is well shown in Figs. 1 and 2,
which give the full-front and side views of the same figure. In
each case, (*a*) shows the fully modeled figures; (*b*) shows the
figure and all its parts enclosed within their proper frameworks;
(*c*) shows the frameworks alone.

5. From these two illustrations it is evident that certain
principles govern the drawing of the human figure. These
principles must be clearly understood and kept in mind at all
times; they are as follows:

1. The human figure is a solid, for it has length, width, and
thickness; it is not, however, a hard, rigid, unbending solid like
a piece of wood or marble.

2. Each individual part, such as the head, the trunk, the
arm, etc., is also a solid.

3. The head may be enclosed within an imaginary block
form slightly longer than a cube; the neck within a half cube;
the trunk, from the neck to where the legs join the body, within
a solid about twice as high as wide but not quite as thick, or
deep, as it is wide; the legs and arms within hinged pairs of
solids, each section of the pair (corresponding to upper arm or
upper leg and lower arm or lower leg) being about twice as long
as wide; and the feet within wedge-shaped blocks as shown.

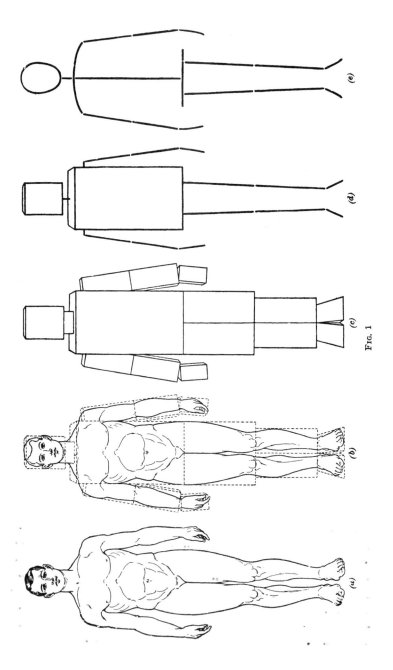

FIG. 1

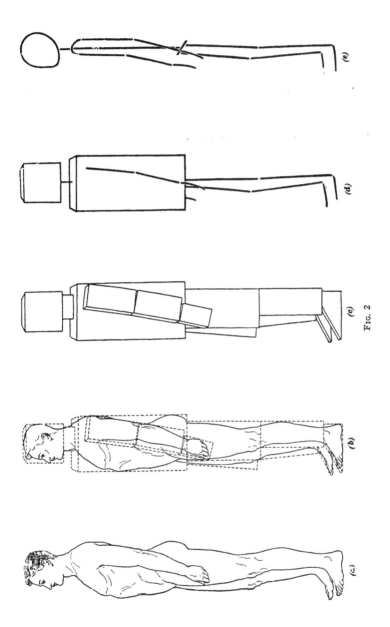

Fig. 2

4. These blocks or solids are not fastened rigidly together at their points of joining, but may be considered as being hinged so as to be able to move in various directions.

If these few general blocking-in shapes are fixed well in mind it will always be possible to think of the figure, no matter how placed or in what complicated postures, as being made up of flexible solids, properly joined, and of the proportions given. The purpose, therefore, of these illustrations is not to furnish a quick method of drawing the figure, but to show the basic framework of the figure and its parts, considered from the exterior.

6. **Foreshortening of Human Figure.**—As people do not always stand erect, soldier like, but assume postures in which one part of the body is much closer to the observer than other parts, the principles of foreshortening must often be applied to drawings of the human figure. The application of these principles, however, is not difficult when the body is thought of as being enclosed within flexible rectilinear solids. Whenever it is desired to show the figure in any foreshortened position, it is simply necessary to draw the proper enclosing rectilinear solid in foreshortened position and then sketch in the enclosed curved lines of the figure.

Suppose, for example, that one were looking at a man stretched out upon the ground, as if he had fallen after being wounded, the feet of the man being nearest the observer. The proper procedure is to sketch a foreshortened square prism, like a 6-foot piece of squared timber, then on this to mark off the proper lengths for the head, trunk, and legs. The rectilinear solids enclosing the individual members may then be drawn in their proper foreshortened positions within the large main solid. It simply remains, therefore, to draw in the contours of the head, neck, trunk, legs, and feet, in their proper enclosing rectangles to complete the foreshortened view of the figure.

7. This procedure must be followed whenever a figure is to be drawn in a foreshortened position, and there is no conceivable position of the figure in which some part of it is not foreshortened. This idea of foreshortening must be kept in

mind all the time as the proportions and characteristic appearances of human figures are studied and when actually drawing human figures in repose and in action. It will then not be necessary to refer to the foreshortening in detail whenever a certain position or action of the figure is being studied; the beginner must observe this foreshortening and must be careful to portray it properly in the drawings he prepares.

8. Study of Skeleton.—In the present study of the framework of the body, the study of the bones and muscles is purposely avoided. That the support and action of the human figure are dependent on the positions of the bones of the skeleton, and that they are held together and moved about by the muscles, is admitted. But the study of these parts is for the student of anatomy and physiology, rather than for the illustrating student. He desires only to familiarize himself with the human figure for use in his pictures. All he needs to know at this time is the result of this bony and muscular posture and action, as it shows typical postures and actions of the figure, as standing, sitting, walking, running, gesturing with arms and hands, etc. The methods of showing such action will be discussed later.

9. Simplified Structural Forms.—The blocked-in forms in Figs. 1 (c) and 2 (c) are too awkward and cumbersome in their parts to be carried in the mind or to be used when sketching human figures. They may, therefore, be reduced to simpler forms by representing the neck, arms, and legs by heavy lines. very much as a heavy bent-iron framework is used as the foundation of large plaster-of-Paris statuary models. The result of this simplification is shown in (d), where only the head and trunk are rectilinear solids, and the neck, arms, and legs are heavy lines. The breaks in these heavy lines indicate the joints at the shoulders, elbows, wrists, thighs, knees, and ankles.

To reduce the block forms to still simpler shapes, the corners of the rectilinear solid for the head may be rounded off to give more the appearance of the actual head and the body indicated by one of the heavy lines or pipes, as shown in (e).

If care is observed to keep the proportions of these simplified figures correct; that is, to see that the arms and legs are not made too long or too short for the body, and that the joints come at the proper places; these simplified forms will be of great practical use when it is required to make drawings from the figure, in repose or in action.

METHODS OF PROPORTIONING ENTIRE FIGURE

10. Figure Based on Center Lines.—Vertical and horizontal center lines are a great aid in the correct proportioning of the human figure, in the same manner as these lines aid in line drawing and when working from wooden models. The following method of procedure will, therefore, be found helpful when proportioning any object or figure as a whole when sketching it.

First, observe and mark off the greatest dimension of the object or figure, whether it is height or width, and then the shortest dimension. Next, locate the middle of the object or figure by vertical and horizontal center lines and note some prominent feature that most nearly corresponds with that middle point. Subordinate details may then be sketched in readily.

The human figure is evenly balanced on each side of a vertical center line that passes down midway between the eyes, over the tip of the nose, the middle of the mouth, chin, and neck, midway between the nipples, down over the navel, corresponds to the inside line of the legs, and ends where the insides of the two heels touch. In an erect front view figure this is a perfectly straight vertical line.

If a horizontal line is drawn for the crown of the figure's head, another for the bottom of the feet, and a third exactly halfway between the first and second, there will be located the bottom of the trunk of the figure; this is the place where the inside lines of the legs join the body. The use of these lines of proportion is clearly shown in Fig. 3, where $a b$ is the vertical center line upon which the figure is equally balanced, $c d$ is the horizontal line for the crown of the head, and $e f$ the horizontal line for the soles

of the feet. Line *g h*—exactly midway between *c d* and *e f*—locates the bottom of the trunk where the inside lines of the legs join the body. This shows how simple and easily remem-

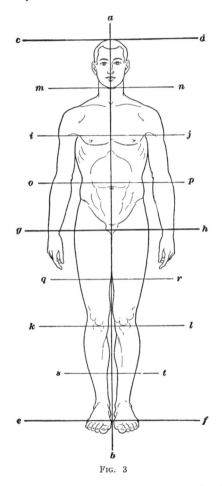

Fig. 3

bered is the first and most important step in locating the proportions of the male human figure.

11. Locating Parts of Figure.—When the figure is divided into two equal parts, the head and trunk and the legs,

the natural inclination is to subdivide these parts in order to locate others. By dividing the upper half, Fig. 3, into two

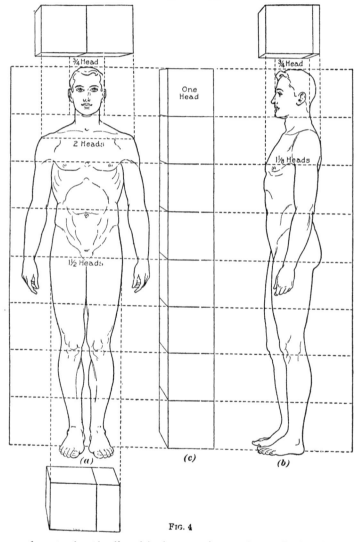

FIG. 4

equal parts, by the line *i j*, the armpits are located; that is, the points where the inside lines of the arms join the body. When

the lower half of the body is bisected by the line $k\ l$, the knees are located.

The figure is now divided into four equal parts horizontally. If the uppermost one of these is bisected by horizontal line $m\ n$, it locates the bottom of the chin; a similar bisecting of the three remaining horizontal fourths locates other points or features of the figure, as at lines $o\ p$, $q\ r$, and $s\ t$. This divides the figure horizontally into eights, which is also the distance from the crown of the head to the bottom of the chin. Therefore, the average human male figure is eight heads high. Some authorities have reduced this to seven for the female figure. This proportion will be used in this figure-drawing training.

12. Proportioning Male Figure According to Heads. To proportion the various parts of the male figure in terms of heads is a great convenience, as the head is one-eighth the height of the entire figure. But the system of heads must not be used for the first blocking-in of the figure. The preliminary blocking-in must be done by first getting top and bottom lines and then a bisecting horizontal line to locate the middle of the figure. If one were to try to lay out the figure by starting with the head and then plotting out the rest of the figure, he would get the figure either too long or too short.

13. Fig. 4 illustrates how the system of heads can be used for proportioning parts. In (a) is shown the front view and in (b) the side view of the figure. In (c) are shown, graphically, eight solids, each of which would contain a head and may therefore be termed *heads*. It will be observed that when eight of these heads are piled one on top of the other they correspond to the height of the male figure; the other proportions are as follows:

HEIGHT OF MALE FIGURE

From top of head to bottom of chin......................	1 head
From top of head to armpits.............................	2 heads
From top of head to bottom of trunk.....................	4 heads
From top of head to knees..............................	6 heads

WIDTH OF MALE FIGURE

Width of head at temples...............................	$\frac{3}{4}$ head
Width across shoulders.................................	2 heads
Width at bottom of trunk (hips).........................	$1\frac{1}{2}$ heads

THICKNESS OF FIGURE

Thickness from front of face to back of neck......... $\frac{3}{4}$ head
Thickness from front of breast to back of shoulder.... $1\frac{1}{8}$ heads
Thickness through waist........................... $\frac{3}{4}$ head

Many other points and proportions can be established with the head as a unit of measurement, such as lengths of arms,

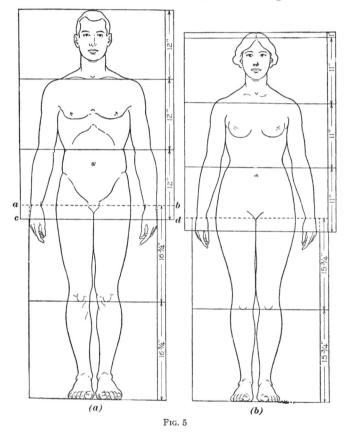

<p align="center">(a) (b)</p>
<p align="center">Fig. 5</p>

hands, and feet, thickness of thigh and calf, etc. But for the present it will only be necessary to familiarize oneself with the proportions given, for with these proportions well in mind the actual drawing of the figure will not be difficult when later such sketching from the human figure is required.

14. Proportioning Figure by Actual Measurements.
Based on averages, it may be said that the average male figure
is 67 or 68 inches (5 feet 7 or 8 inches) tall, and the female figure
63 or 65 inches (5 feet 3 or 5 inches) tall. These average actual
measurements, however reliable and exact, cannot in themselves
be very useful to the illustrator, for the simple reason that he
must always foreshorten parts of the figure. He must, there-
fore, depend on relative proportions; for he can foreshorten
these. However, a knowledge of actual measurements reveals
a system of proportions that not only locates points in the body
not previously obtained, but establishes a system of workable
proportions that is always used in practical work. Further,
these show clearly the difference between the proportions of the
male and the female figures. These accurate measurements
reveal that the line of the shoulders and the line of the waist
fall about at thirds between the crown of the head and a little
below the extreme lower end of the trunk. These measure-
ments are shown in Fig. 5 (a) and (b).

15. A careful study of Fig. 5 (a) and (b) will reveal the
relative heights and proportions of parts of the average male and
female figures. If the horizontal line a b, view (a), that
bisects the male figure is dropped a little, say 2 or 3 inches, as
shown by the line c d, the distance from the top of the head to
the extreme bottom of the trunk is found to be 36 inches. By
dividing this distance in three parts of 12 inches each, the shoul-
ders and waist will be located.

In the female figure, shown in (b), the corresponding distance
is 34 inches. By allowing the 1 inch in excess in the top sec-
tion and dividing the rest of this distance into three parts of
11 inches each, the shoulders and waist will be located. The
lower half of either the male or female figure need only be
bisected horizontally as before to locate the knees.

Fig. 6 shows the application of this principle to the rear view
of a figure.

16. Practical Application of These Proportions.
When actually drawing the figure, whether from life or from
memory, the proportions that are used are those shown in

Figs. 4 and 5. The figure illustrated in the frontispiece is properly diagrammed from a photograph of the statue of an ideal figure (John Borgeson's "The Crocus"). A photograph of a professional model might not indicate the general proportions of an ideal figure, and is not suitable here for the purpose of head heights. Study the frontispiece simply for method of blocking in.

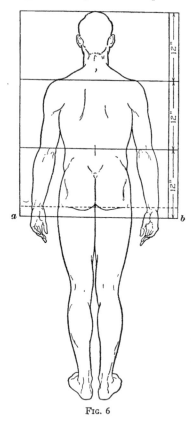

FIG. 6

Note again that the eight-heads height applies only to the classic female figure. The average living female model is considered as being seven heads in height.

First, in the male figure the lines for the top of the head and the soles of the feet are sketched in, the horizontal center line that locates the bottom of the trunk is placed in, and then the other horizontal lines are placed, establishing the position of the bottom of the chin, the horizontal center line of the breasts, the line of the navel, the line half way from the bottom of the trunk to the knees, the line of the knees, and the line half way between the knees and the soles of the feet. Later, actual practice will be given in proportioning the male figure eight heads in height, and the female figure seven heads in height.

How the dropped-horizontal-line system works is shown graphically in Figs. 7, 8, and 9. In Fig. 7 is shown a rear view of the female figure. The lines establishing the top of the head, shoulders, and waist are slightly inclined away from the horizontal because in these views of the figure the head, shoulders,

and waist of the figure are tipped toward the right. The line for the bottom of the trunk is horizontal, because this part of the figure is in its normal position The line for the knees is sharply tipped because the left knee is lower than the right one (in the drawing) because of the position of the legs.

In Fig. 8, which is a front view of the female figure, the principle is again applied. The division lines to mark positions

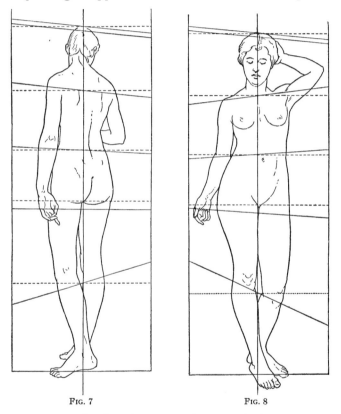

FIG. 7 FIG. 8

of parts are again tipped because these particular parts of the figure are tipped, as shown.

In Fig. 9, the principle is applied to the seated female figure. In such a case, the distance to be divided into thirds is from the crown of the head to the seat. When so divided, the shoulders

and waist are located as before. It will be noted that the knees, even in the seated figure, are midway from the bottom of the trunk to the soles of the feet.

17. Comparative Proportions of Child and Adult Figures.—The proportions of the human figure that have been given are those of the adult figure, and of course are those that are most needed by the illustrator, as adult figures are most common in illustrations. However, as occasions for the use of

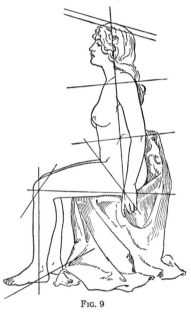

FIG. 9

figures of infants and children frequently arise, the illustrator should know the relative proportions of parts in the infant and the child body. It is common to see drawings of children in which the head is disproportioned to the rest of the body, or the legs are too long; and the young illustrator must be prepared to avoid such errors.

Fig. 10 (a) to (d) shows the figures at various ages. View (a) is an infant of 6 months; (b) a child of 5 years; (c) a youth of 9 years; and (d) an adult. It will be noted that as the age increases, the relative proportion of head to body, expressed

in number of "heads" increases. At 6 months, view (*a*), the child is only $3\frac{3}{4}$ heads high; at 5 years, view (*b*), about $5\frac{1}{2}$ heads high; at 9 years, view (*c*), about 6 heads high; and in the adult, view (*d*), 8 heads, as previously discussed. Expressed conversely, this means that the infant's head is quite large for the body, the 5-year-old child's head (while actually larger than the infant's head) is relatively smaller as compared to its body;

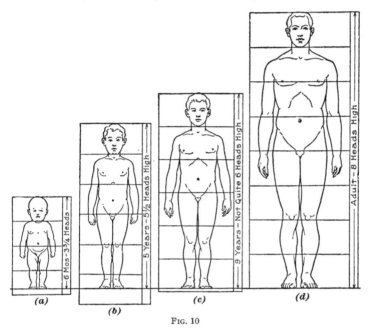

Fig. 10

the 9-year-old youth's head is still relatively smaller; and the adult's head is smallest of all, as compared to the size of the body.

It must be remembered, also, that in extreme old age, the body diminishes somewhat in height; not only on account of the stooped posture that often comes with old age, but because of the sagging of muscles and tissues. However, one who becomes familiar with the proportions of the normal adult figure in the prime of life can readily make the alterations in proportions, as well as in drawing of individual parts, so as to portray old age properly.

METHODS OF PROPORTIONING PARTS OF FIGURE

IMPORTANCE OF INDIVIDUAL PARTS OF FIGURE

18. The framework of the human figure as a whole, and the placing and proportioning of its various parts in relation to the entire figure and to one another, have been discussed so far. However, before one could expect to make an accurate drawing of the figure either from life or from memory, he must have a

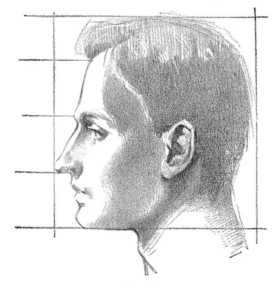

Fig. 11

more detailed knowledge of just what is the construction and appearance of each individual part or feature of the human body. Having familiarized himself with all these details he is then ready to combine them; to draw the head, the neck and shoulders, the breast and abdomen, the arms and hands, the thighs, the legs, and the feet, each one of proper size and properly rendered, and in harmonious relation to the entire figure and to every other individual part.

THE HEAD

19. Profile View.—Viewed in profile, the head may be enclosed in a perfect square; and, in either profile or in full-face view, the face divided into thirds from the roots of the hair to the chin, as shown in Fig. 11. These thirds may be marked: *1*, from the roots of the hair to the brows; *2*, from the brows to

Fig. 12

the base of the nose; and *3*, from the base of the nose to the bottom of the chin. The distance from the crown of the head to the roots of the hair is one-fifth the height of the head. These measurements vary with each individual and cannot be taken

absolutely, but for general drawing may be considered as a basis for construction

20. Full-Face View.—In the front, or full-face, view, the head may be considered as five eyes in width, the space between the eyes and on each side occupying a distance equal to the length of the eye itself. If a cross-section of the head were made at the height of the eyebrows, it would be nearly oval in shape with the fulness in the back; the ordinary band of a hat illustrates this. If a piece of tape is tied around the head at the line of the brows so that it touches the tip of the ears it will describe an oval and form a means of locating certain features of the face when the head is thrown backwards or for-

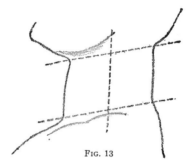

FIG. 13

wards so as to change the relative position of the features, as shown in Fig. 12. Thus, in drawing the head from any standpoint, whether the eye is far beneath, looking up to the model, or above, looking down on him, the brows and tips of the ears will always follow this oval strip, or tape, and can always be accurately located. However, the human head is so varied in proportion that it must be drawn as seen, irrespective of any set rules, for adherence to them is likely to be productive of a stock face or figure that soon becomes devoid of interest and novelty.

NECK AND SHOULDERS

21. After placing of head, the neck and shoulders must be considered; a line from the point of one shoulder to the point of the other gives the general direction. Where the

neck joins the back of the head it rises much higher than at its junction with the fleshy part of the face under the jaw, but the junction of the neck with the back at the line of the shoulders is correspondingly higher than its junction at the pit of the throat. Thus, the column of the neck has a downward, oblique direction from its points of junction in the back to its points of junction in the front part of the body, as shown in Fig. 13.

The shoulders, which in the common acceptance of the

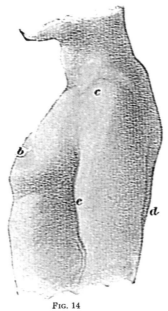

FIG. 14

word, include all the space from the neck to the muscle that caps the end of the bone of the upper arm, rise above the collar bones, and form a sort of muscular defense for them.

BREAST AND ABDOMEN

22. Muscles of Breast.—The two rather massive prominences on the breast of the male figure, shown at *b*, Fig. 14, are the breast muscles. They are separated by a slight indentation or hollow extending from the pit of the throat downwards.

In repose, their surface is unbroken by any muscular markings, but under strong action they are well defined. Their contour is indicated by the shape of the shadows that fall on them. The various forms on the chest are very readily located by the relative positions of the nipples, which in the standard male figure are one head below the chin.

23. Muscles of the Abdomen.—Beneath the massive breast muscles, on each side of a perpendicular line, are the muscles of the abdomen. These also are somewhat indistinct when in repose, and are frequently obliterated entirely by an excess of fat. In the thin or muscular figure they are sharply defined when in action and appear as three separate masses on each side of a median line from the base of the breast muscles to the bottom of the trunk.

24. The Female Breasts.—In drawing the breasts of a female figure, the forms and shadows are very subtle. In the front view, where there are no contouring outlines, the expression of these details depends entirely on the careful rendering of the marginal shadows and the correct estimate of their proper tones. The position of the nipples and their relative position to the navel should be accurately determined, as these three points are of primary importance in the construction of the torso, or trunk, of the figure.

SHOULDER, ARM, AND HAND

25. Bones of Arm and Hand.—In the upper part of the arm there is a single large bone called the humerus. At its upper extremity it joins the shoulder, and at its lower extremity it unites with two smaller bones, called the ulna and the radius, and forms the elbow. The ulna and the radius unite at the wrist with several smaller bones that extend to the joints of the fingers. In the construction of the forearm, as the lower portion of the arm is called, the radius is on the side of the arm that connects with the thumb, while the ulna is on the side that connects with the little finger.

26. Muscles of Shoulder and Arm.—Over the shoulder joint where the humerus connects with the clavicle is stretched the deltoid muscle, which caps the shoulder like an epaulet, as shown at *c*, Fig. 14. The biceps muscle *e*, which is that one made prominent in the front of the upper arm, is forwards of the humerus, and the triceps muscle *d*, corresponding with it on the back of the arm, is on the opposite side. Thus, the upper arm is deeper than it is wide owing to the fact that these two muscles lie on opposite sides of the bone, and its greatest dimension is seen when viewed from the side.

27. Pronation and Supination.—When the arm is in the act of *pronation*, that is, in the position shown in Fig. 15, the muscles of the forearm assume a widely different appearance from that seen when the arm is in the act of *supination*, as shown in Fig. 16. During pronation the position of the bone of the forearm is distinctly seen by the shadow that runs to the point of the elbow. During supination the bone is not seen, and the shadow shown is under the muscle. The contours on the upper and lower lines are changed completely, especially about the wrist. Familiarity with these forms is only reached through long practice in drawing from the figure and close observation. Therefore, the details of the arm in both these attitudes should be carefully studied, so that the memory will be stamped with the difference in the contours of the muscles. In pronation, the forearm has reached what is practically its extreme limit of range in one direction, and in supination it has reached the extreme limit in another direction. There are varieties of action between these two extremes that change the position of the muscles to such an extent that one must be thoroughly familiar with them in order to have the arm in good drawing, no matter in what position it may be.

28. Arms in Various Positions.—In Fig. 17 is shown the male arm as seen from a low point of view, in consequence of which it is considerably foreshortened. The shoulder cap, or deltoid muscle, here becomes clearly defined, and the muscles of the forearm are shown rigid and full near the elbow, owing to the fist being clenched. The shadow on the inside of the

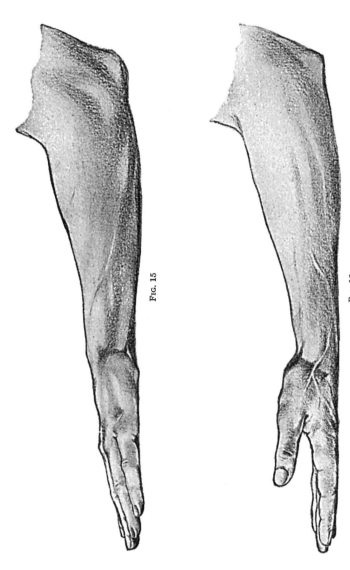

Fig. 15

Fig. 16

arm indicates the intersections of the planes that give the contour in this position.

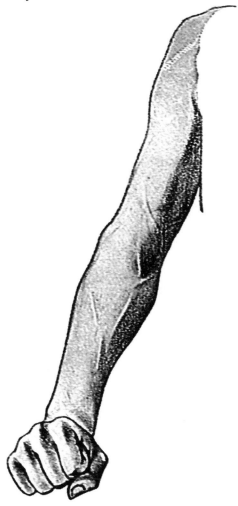

FIG. 17

In Fig. 18 the female arm is shown with a clenched fist. By being drawn up tight against the upper arm, the forearm is given a fulness near the elbow that is seen in no other position.

The characteristic smoothness of the female arm is also shown. Even in this position the muscles are not knotty and hard as in the male arm, but the curves round off gracefully, one into the

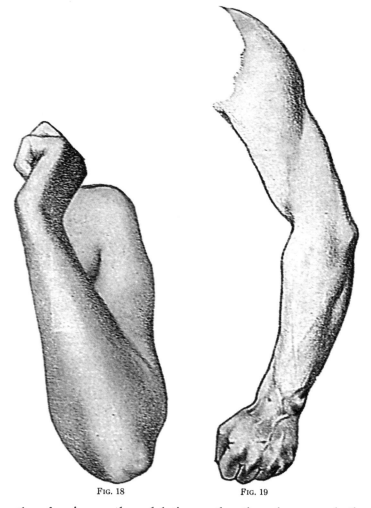

FIG. 18 FIG. 19

other, forming gentle undulations rather than sharp, emphatic curves. This is a characteristic that distinguishes all the contours in the female figure from similar contours in the male figure.

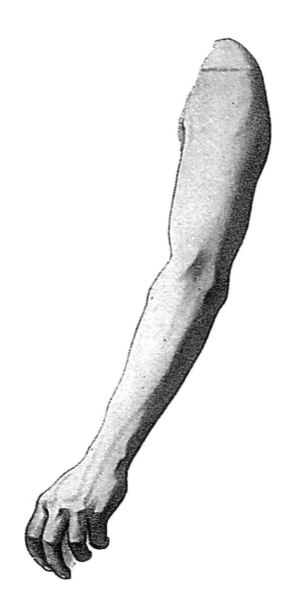

Fig. 20

29. Fig. 19 shows a muscular arm of the male figure, the development of which is clearly shown. The deltoid muscle of the shoulder can be seen reaching like an epaulet from the top of the shoulder to the side of the arm and entering it in a blunt point between the biceps muscle and the triceps. The triceps bulges slightly at the back of the arm, but its fullest part is nearer the shoulder than the nearest part of the biceps. The muscles of the forearm are emphasized, as in Fig. 19, by the clenching of the fist, but if the hand were gradually opened the muscles on each side of the forearm would gradually flatten out and the fulness of the forearm spread somewhat toward the wrist.

Fig. 20 shows the male arm in a relaxed state, but the muscular development is sufficient for one to observe the power contained therein. Down the full length of the arm the plane of shadow indicates the shape of the muscular forms beneath the skin and follows each concavity or convexity of surface on the side away from the light. The position of the elbow becomes marked by a sharp angle in the shadow, while on the back of the hand each knuckle and joint is expressed by a modeling of small planes of light and shade. This illustration will bear careful study; the prominent bone on the outside of the wrist and each of the joints of the fingers are expressed by a little plane of light located in just the right place.

30. Fig. 21 shows the construction of the arms and location of the planes of light and shade, when these members are seen from behind. The muscular development is slight and the position one of complete inaction and listlessness. The feeling of inaction is expressed by the flatness of the muscles and the evenness of the curves from one plane to another. Note the creases and folds in the skin that give character to the elbows and also to the expression of the ligaments in the wrist as they run from the muscles of the forearms to the fingers. Though none of the muscles are contracted, the plane of shadow on the inside of the left arm shows all the gradations of bone structure and muscle, and in many cases will even indicate the form, branching, and general distribution

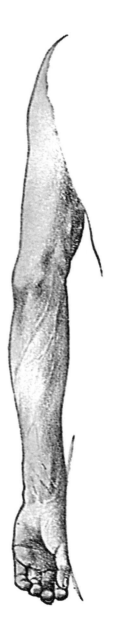
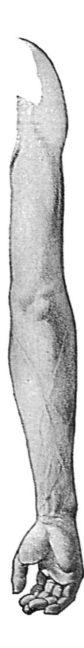

FIG. 21

of the veins. In the right arm note particularly the thin appearance of the upper part; this is due to the fact that the biceps and triceps are set one before the other with the bone between them, so that the smallest dimension of this portion of the arm is shown. But the position of the forearm is such that the bones and accompanying muscles are seen from their widest standpoint. The relative widths and positions of the various proportions of the arms as they are turned in different positions should be carefully studied.

In Fig. 22 is shown a profile view of the female right arm, The upper arm appears rather short for the forearm, owing to the fact that when making this drawing the model was placed far above the eye. This foreshortening gives the effect of elevation to the figure. The left arm resting upon the small ot the back shows the smooth, graceful curves of the outside line of the female arm in this position, contrasted with the sturdy and abruptly changing planes of the male arm. In both the left and right arms, the unbroken smoothness of line characteristic of the female figure is strongly illustrated.

31. In Fig. 23, the thin, undeveloped arms of a young girl are shown. Here the chief interest centers in the foreshortening of the forearms and of the hands. In the model's right arm the wrist is entirely hidden, and unless the arm and elbow, as seen to the left and below it, are properly rendered the unity between the hand and the arm will not be expressed. This should be very carefully studied. In the model's left arm nothing is hidden, but the foreshortening must be carefully studied and the work must be very accurate. In this position the hands appear larger than they would ordinarily, as they are from 8 inches to 12 inches nearer the eye than is the elbow. No set rule can be given for this foreshortening, but attention must be given to the proportions of all the parts in order that the foreshortening may be expressive of existing conditions.

32. The Hand.—The appearance of the hand is so influenced by foreshortening in all positions that actual measurements of its proportions are of little value. The forefinger and

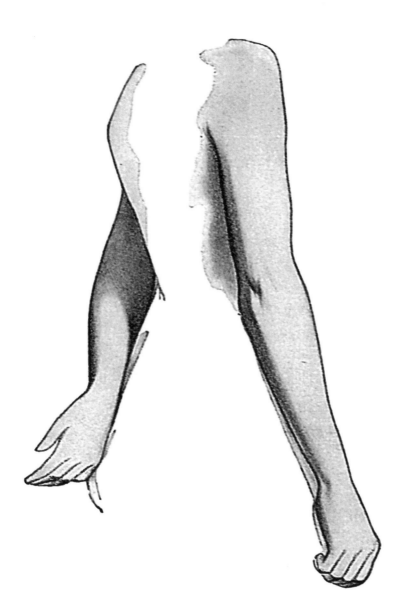

FIG. 22

the third finger are usually of about the same length, and the distance from the knuckles of the forefinger to the joint of the wrist is approximately the same as the distance from the knuckles to the tip of the finger. The middle finger is longer than those next to it, and the little finger is the shortest of the four.

The characteristics of the hand naturally vary with the individual. In the clenched fist the forms are very similar

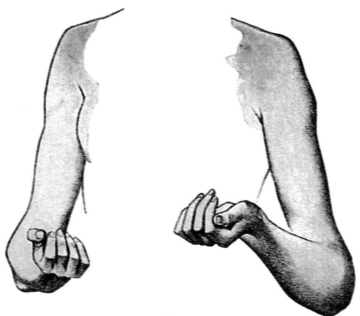

Fɪɢ. 23

to those of a plain block hand, and in drawing details of the hand the same rules apply as in drawing the head or other parts of the figure. The mind and eye seize on prominent points for starting and finishing lines. These points vary with the position of the hand, but generally speaking, the wrist, knuckles, and first and second joints of the fingers and thumb are to be located first and the construction built around them, close drawing of the contours may then follow. The shadows

should be carefully modeled so that their margins will be well
defined, as the solidity of appearance is dependent entirely
on the accuracy with which these shadows are handled. Illus-
trations of hands in various positions are shown in Figs. 5 to 23,
inclusive, which should be carefully studied.

THE THIGH, LEG, AND FOOT

33. Location of Principal Muscles.—When studying
the thigh, it is well to know where certain muscles are placed,
although this member is usually so covered with fat that it
is difficult to find lines of separation between the various
sets of muscles. When the thigh is made rigid by strong
action it will be seen that on the outside of the upper part
of the thigh a large muscular prominence forms a ridge that
extends obliquely across the leg, from a to b, Fig. 24 (a), so
that when it reaches a point above the knee it is on the inside
of the leg. This ridge is made up of several large muscles,
but their origin is difficult to trace on the figure, and conse-
quently in rendering the thigh the eye must carefully search
for shadows and their outlines in order that all may be intelli-
gently expressed.

34. Muscles of Upper Leg.—The large muscle on the back
of the thigh is known as the biceps of the leg, and has a use similar
to that of the biceps of the arm; that is, to draw the lower por-
tion of the leg upwards and toward it. Its prominence is
plainly seen when the leg is viewed from the side and gives the
thigh, similar to the arm, a greater depth than thickness. The
upper bone of the leg is called the femur and unites with two
smaller bones in the lower portion of the leg, called the tibia
and the fibula.

**35. Comparison of Male and Female Thighs and
Calves.**—Fig. 24 shows the comparative proportions of the
male and female thigh and leg when viewed from nearly the
same standpoint. Assuming the calves to measure practi-
cally the same in circumference, it can readily be seen that
the female thigh and knee are rounder and larger than the

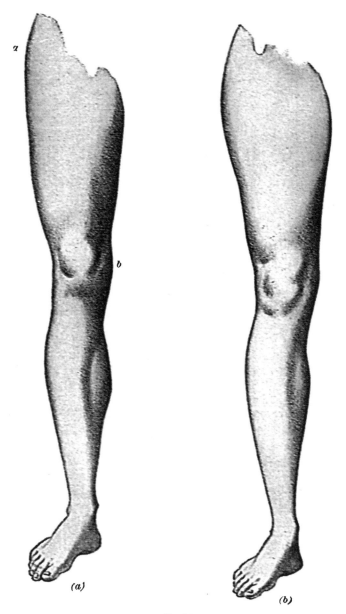

FIG. 24

male and that the lines causing this appearance are on the outside of the leg. On the outside line of the lower leg, however, the contours are nearly the same; but on the inside line the most prominent point of the calf is higher and considerably greater in the male figure than in the female. This difference of appearance is due largely to fat filling the space below the knee in the female figure, the muscular development of the male being more defined than that of the female.

In comparing these two legs one can see the characteristic difference between the male and the female figure, the former being sharply contoured and muscularly expressive, the latter being soft and undulating in its form. Study, line for line, these two legs; they will be found to possess at nearly the same points exactly the same curves and in the same directions, but the gradations from one curve to the other are much more delicate in the female than in the male leg. Here, too, can be observed the cause of the appearance of knock-kneedness so prevalent in the female figure, the outside line of the leg exhibiting a greater indentation at the knee in the female than in the male figure. If a straightedge, however, be laid along the inside of each of these legs from the ankle bone to the top of the thigh, it will be found, as a matter of fact, that neither is in the slightest degree knock-kneed, but that the female leg is a trifle the reverse if anything.

36. Muscles of Lower Leg.—The three principal muscles of the lower leg are the two large ones that form the calf, and a smaller one in front of the shin bone. Viewed from the direct front, the prominence of the calf is very marked. Its most prominent part on the outside of the leg is somewhat higher than its most prominent part on the inside of the leg, as may be seen in Fig. 24. In rising on the ball of the foot these muscles are brought sharply into prominence, and when seen from the back of the leg their form is very clearly defined. The shin muscle is brought into prominence by placing the heel firmly on the floor and drawing the foot upwards as far as possible. In profile, or side view, the shin muscle curves slightly forwards from the bone, and the greatest width of the calf is

slightly higher than a point midway between the kneepan and the sole of the foot, as shown in Figs. 25, 26, and 27.

The position of the foot governs the appearance of the muscles of the leg in identically the same manner as the position of the hand governs the muscles of the arm. With every turn of the foot the points of muscular prominence vary.

37. The muscles on the inside of the leg are seldom as well marked in women as in men, the lines being much straighter on the inside, as a rule, and more curved on the outside. The shaping of the muscles themselves, however, is practically the same, and the difference of appearance between the male and female is due almost entirely to the filling in of fat. Owing to habitual exercise, due largely to the difference of amusements among male and female children, the male muscles become strongly developed and less fat fills in between them. In the adult's leg, the male is characterized by a development that clearly locates the position of each muscle; in the female, the curves of the leg are continuous and the delineation of the muscles can be traced with difficulty.

There is a common tendency in the male figures toward a separation of the knees giving a bow-legged appearance, while in the female figure the tendency is toward a knock-kneed appearance. This latter is intensified by the fact that the hips of the female figure are very broad, and the lines from the hips to the knees taper very rapidly. Thus, this knock-kneed appearance exists even where, as a matter of fact, the limbs are perfectly straight.

38. Characteristics of Male Legs.—Fig. 25 is a drawing of the muscular male legs with the weight of the body thrown forwards, thus bringing into prominence the muscle of the front of the right thigh and a fulness of the shin muscle directly below the right knee. The left leg exerts a backward pressure in this action principally on the toes and ball of the foot, and the clean definition of the thigh muscles just above the knee shows where the greatest strain comes. The muscles on the inside of the left calf also suggest pressure, and the expression of action in this figure is due entirely to the modeling

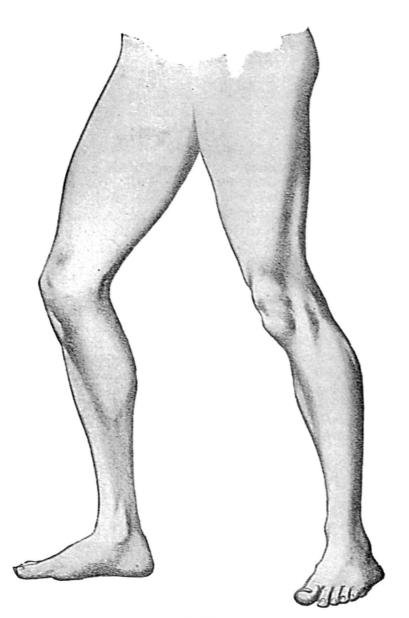

Fig. 25

about the knees and along the sides of the legs that shows the tensity of this muscle.

In the left leg, the curve of the shin bone from the knee down is strongly indicated by the shadow on the inside of the muscle. The right foot is in full profile here, while the left foot is foreshortened in front view, and forms an excellent study in the relative points of prominence in the ankle, both outside and inside.

39. Fig. 26 is a study of modeling to indicate the muscular forms in the male limbs when viewed from the side and posed somewhat as in Fig. 25. The definition of the kneejoint and kneecap is very clearly marked here and the ankle bone stands out with great prominence, showing the point of hinge or turning at this member. The depression above the knee-cap in the left leg appears here, giving fulness to the muscle above it in the same manner as in Fig. 25, but the point of view being farther to the right than in Fig. 25, the prominence on the inside of the calf is entirely lost sight of.

When studying from the model, at all times, advantage should be taken of opportunities to walk around it and notice the change of contour at each step. As one steps to the right or left of the point of view, certain muscles become foreshort-ened and others come into prominence, and it is only by the careful study of these that correct delineation can be given to the subtle character of the human figure. It is only by this study and the repeated drawing from the figure in these positions that the details can be impressed on the mind suffi-ciently to permit the correct delineation of forms in illustra-tive work.

40. Fig. 27 is a direct view of the prominent points on the inside and outside of the left leg when seen from behind. In the outside of the thigh, there is very slight convexity; while in the line of the inside, there is a slight concavity about mid-way to the knee. The point of prominence in the outside of the calf is higher than the point of prominence on the inside of the calf; the location of these points of prominence is an important detail that should be studied from the living model, as the

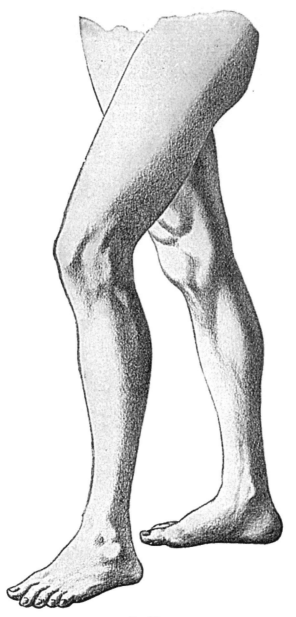

Fig. 26

position of the feet has a strong influence in the general contour of the leg. For instance, in Fig. 27, the foot of the left leg rests at a given angle, thus causing the contours of the leg to assume a certain definite form, but the foot of the right leg is turned outwards and the contours of this leg are considerably changed. Not only is it important to establish these contours correctly in order to satisfy the eye as to the accuracy of the drawing, but the shadows indicating the planes must be well placed, or the whole composition will be incongruous and unsatisfactory.

41. Characteristics of Female Legs.—In Fig. 28 the smooth, unbroken quality of the outline contour is strongly indicative of the female figure. The flesh is laid so smoothly over the muscles that their characteristic prominences are almost entirely hidden. A comparison of the rounded, undulating forms here with the knotty, muscular development of Figs. 25 and 26 again illustrates the distinguishing characteristics of the male and female figure. Here, as in Fig. 24, the thigh is shown round and full, and the construction here and in the knees is almost entirely obscured by the presence of fat. The width of the hips is especially noticeable, although the figure for the most part is rather slight.

Fig. 25 showed a profile of the right foot as seen from the inside; here is shown a profile of the left foot as seen from the inside. The one being male and the other female, however, there are slight differences in contour, but the rise of the ankle from the instep and heel can be profitably studied from both points of view.

42. In Fig. 28 the comparative size of the thigh and calf of the female figure are well shown. Owing to the anatomical character and great width of the female hips, a large thigh is a necessity in order to give grace to the leg; otherwise, the lines from the hips to the knees would be concave, giving an appearance of awkwardness and weakness. Here can also be observed another characteristic that offsets this tendency to weakness in appearance; that is, the fulness of the calf on the outside and the tendency of the same to a

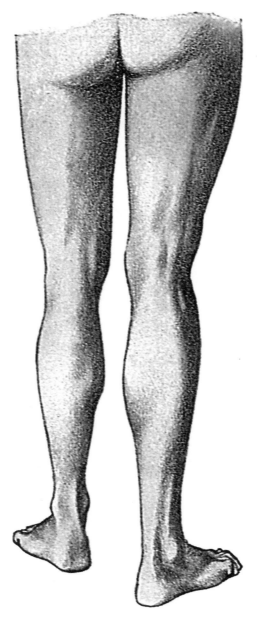

FIG. 27

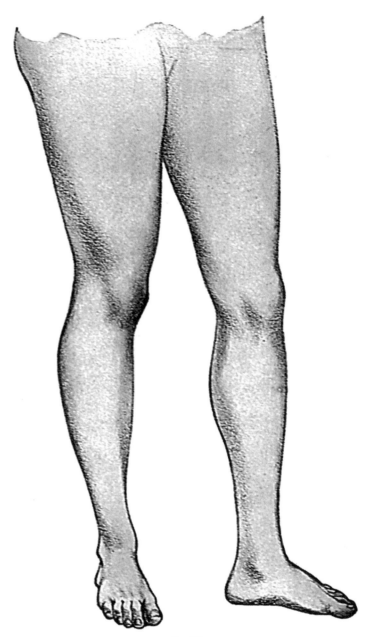

Fig. 28

straight line on the inside. The foot here is in full front view, and the right leg is shown foreshortened, as seen from a point considerably above its level, while the foreshortened left foot in Fig. 25 was seen from a point very little above its level. In the right foot shown in Fig. 28, two prominent points of the ankle bone should be studied carefully. Whenever opportunity arises this should be studied from the living model, inasmuch as the points of prominence on the inside and outside vary constantly with changes of position.

43. The Foot.—When drawing the foot in profile, its length should be estimated by comparison with some fixed scale of measurement, such as the head, or by the proportion

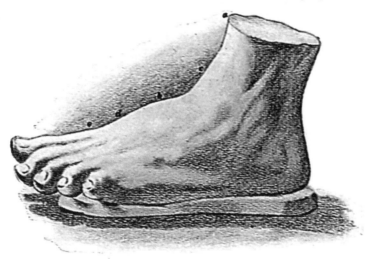

FIG. 29

it bears to the length of the leg from the knee to the sole of the foot. The contour of the instep, the position of the ankle bone, and the shape of the heel are next in importance.

Fig. 29, which is a reproduction of a charcoal drawing from a plaster cast of the foot, shows the curve of the instep, *e d b*; and the contour of the front of the ankle, *a c*. The positions of the toes as seen in profile should also be studied with great care. Views of the foot in still other positions are shown in

Figs. 24, 25, 26, 27, and 28, and these also should be studied. In direct front view it is particularly important to observe the size and position of the toes and the relative position of the outside and inside prominence of the ankle bone.

THE FACE AND ITS FEATURES

44. Importance of Features of Face.—The most important of all the parts of the body, in the consideration of the artist and the illustrator, are the human face and its features. It is the features of the face that portray the real story of the picture; for it is the expressions portrayed on the faces of the characters that make or unmake the illustration. Expressions of the face, however, are simply the various facial features made mobile and placed in different positions and relations to one another, by the action of the various muscles. It is evident, therefore, that before expressions can be portrayed intelligently, the artist must know the shapes and positions of the individual facial features in repose and how to draw them. For instance, the eye itself, without any of its accompaniments, has no expression. But, when the muscles around the eye do their proper work under direction from the brain, all the varied expressions of love, pity, fear, grief, indignation, joy, etc., are observable and can be portrayed in illustrations.

THE EYE

45. The Eyeball.—The correct drawing of the human eye is one of the most difficult problems in figure drawing. The convex shape of the eyeball enveloped by the lids is full of subtle variety when foreshortened, while the spherical shape of the eyeball proper causes the lids and other details to be somewhat foreshortened at all times, no matter in what position the eye may be seen.

In general structure the eyeball protrudes from a socket, or *orbit*, as it is called, and is enveloped above and below by the eyelids, as shown in Fig. 30. The plane of this orbit slopes

inwards as it descends to the cheek bone, as shown at *a b*, Fig. 31, and makes an angle with the plane of the forehead as the latter recedes from *a* to *d* and also with the plane of the cheek as that passes forwards, as shown at *b c*. Each detail of the eye, whether it is opened or closed, tends to preserve the direction of the plane *a b*, and the eyeball never protrudes sufficiently from its socket to disturb the slope. The upper lid extends beyond and partly covers the upper portion of the iris, while the iris slopes backwards with the plane of the orbit. The under lid is thinner than the upper and forms the base of the plane *a b*, where

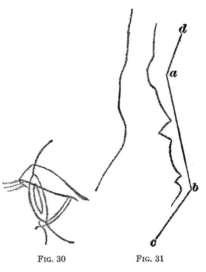

FIG. 30 FIG. 31

it intersects with the cheek plane shown by line *b c*, Fig. 31.

The eyebrows start either side of the nose just under the frontal bone and extend outwards and slightly upwards, tapering gradually toward the temple, where the growth ceases on the outside of the orbit, as shown in Fig. 32.

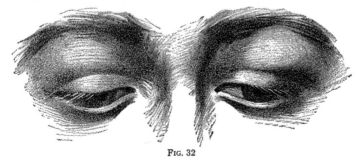

FIG. 32

46. **The Eyelids**—The convexity of the eyeball determines the curvature of the eyelids, but this curvature changes with every position of the head, owing to the foreshortening.

In a three-quarter view, the upper lid makes a spiral turn
that hides its thickness at the outside, as shown at a, Fig. 33,
while in looking downwards the upper lid straightens out
and the lower lid becomes more convex, owing to the fact
that the eyeball is rolled into the lower lid. As the eye is
turned downwards the outer corner descends slightly also,
tending to straighten out the lower lid. When the eye is rolled
upwards the convexity of the eyeball is emphatically marked

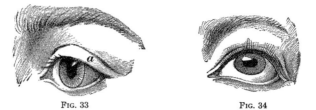

FIG. 33 FIG. 34

by the upper lid, as shown in Fig. 34; its breadth is dimin-
ished, but its thickness is visible all the way across, while
the lower lid flattens out and forms a compound curve rising
from the inner corner and descending until past the pupil,
when it rises abruptly to the outer corner. With most persons
the upper lid is more convex on the inside than on the outside,
while the lower lid is more convex on the outside. From
the outside of the corner of the eye the upper lid curves slightly

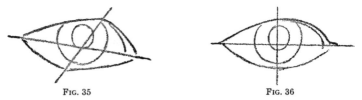

FIG. 35 FIG. 36

toward the top of the iris and then descends in a more or less
abrupt curve to the tear gland by the nose, while the lower
curve starts straight from the tear gland, descends slowly,
and returns in a rather more abrupt curve against the outer
corner of the upper lid, so that lines drawn through the points
of start and finish in the eye will intersect about as shown in
Fig. 35. The eye very rarely composes itself into two even arcs
from corner to corner, as shown in Fig. 36.

THE NOSE

47. Profile and Front Views.—Viewed directly in profile the nose starts beneath the eyebrows and proceeds at an angle until the tip is reached. The character expressed by it is mainly influenced by the bridge, while the terms Roman, straight, aquiline, and retrousse (turned up) are based on the degrees of convexity or concavity of the line from the brows to the tip. The upper lip joins the cartilage, or partition, between the nostrils at a point about midway between the extreme tip of the nose and the crease where the wing of the nostril joins

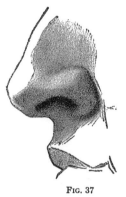

Fig. 37

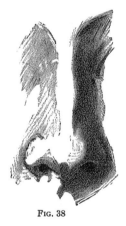

Fig. 38

the cheek, Fig. 37. When illuminated by a strong light, the margins of the shadows definitely describe and locate the planes that make up the construction of this feature.

In a full-face view, Fig. 38, the nose has its origin between and somewhat beneath the brows. At its beginning it is narrow and increases in width at the bridge; it decreases where the cartilage is reached at the end of the nasal bone, but again increases, attaining its greatest width at the tip. The nose is wedge-shaped from this view, with the edge of the wedge to the front; the sides slope gradually from the bridge to the cheeks until the nostrils are reached. The base of this wedge extends outwards from the general plane of the face, as the nose is much broader at the base than at its

origin between the brows. If this point is not well understood, drawings of the nose are likely to look as if the nose were pressed

into the face between the cheeks. A block form of the nose is shown in Fig. 39. A sharp crease marks the formation of the wing of the nostril at the base and lessens in prominence as it extends into the cheek. The greatest width of the nose is at the base across the nostrils.

Fɪɢ. 39

48. Foreshortened Views.—When the nose is seen on a level with the eye the cartilage between the nostrils extends slightly lower than any other part, Figs. 37 and 38. When viewed from below, however, the wings appear to be the lowest part, as in Fig. 40 (*b*); but viewed from above, the nostrils

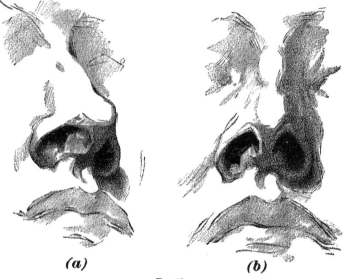

(a)　　　　　　**(b)**

Fɪɢ. 40

are completely screened, and the lower part of the tip overhangs the upper lip, Fig. 41. When the head is thrown well back, as in Fig. 40, the formation of the nostrils and the intervening cartilage can be easily studied. The unconventionality of these

forms makes definition difficult, and much practice in drawing
them is therefore very necessary. The convex surface of the

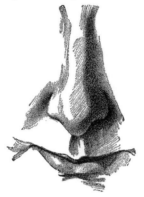

FIG. 41

wings and the end of the nose should be studied in profile, full-
front, and foreshortened views. The shadows on these forms

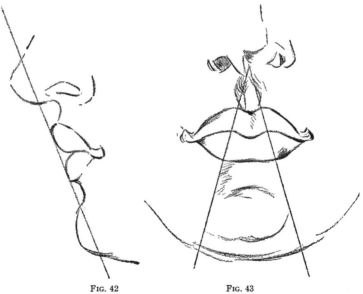

FIG. 42 FIG. 43

better illustrate their character than any verbal description
can possibly do.

When seen from below, the bridge from the brows to the end will lose greatly in length by foreshortening, and must therefore be carefully studied in order to avoid an exaggerated appearance.

THE MOUTH

49. Profile and Front Views.—The mouth, like the eye, is one of the most difficult parts of the face to render properly, inasmuch as its form is so subtle and so greatly influenced by foreshortening that constant practice is the only

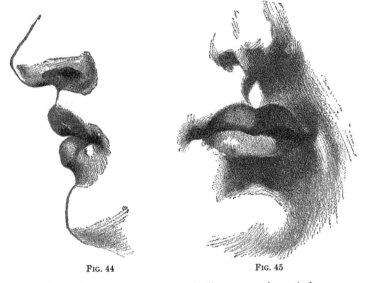

Fig. 44 Fig. 45

means by which one can successfully master its subtle curves. Viewed in profile, Fig. 42, one can study the general formation of the lips. Note the steps formed by the intersections of the nose, lips, and chin with the plane of the lips. In the full-front view, Fig. 43, the upper and lower lips are seen to be concave in their outlines from the middle to the corner. In thickness, the upper lip is much more convex than the lower one, Fig. 42, and the curves unite in a very subtle manner with adjacent curves. In the average mouth, the upper lip overhangs the lower lip slightly, and in a direct profile view, Fig. 44,

the corners will be found somewhat lower than the drooping middle portion of the upper lip. In the full-face view, Fig. 45, the mass about the mouth is very convex owing to the influence of the teeth. The corners, therefore, are farther back than the middle and the concave sides become foreshortened. The red portion of the upper lip may be divided into two planes a and b, Fig. 46, while the lower lip possesses three planes, the middle one c extending each side of the center of the upper lip and the two side ones d extending into the corners of the mouth. The degree of curve and fulness in the lips is a matter of individual character, varying from a distinct bow shape to lips that are so thin and straight as to be scarcely more than a straight line across the face.

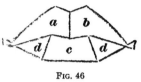

FIG. 46

50. The concavity beneath the lower lip is largely influenced by the fulness of the lip itself and the pressure brought to bear on it by the upper lip. Viewed from the front, Fig. 45, the depression that divides the upper lip beneath the nose widens as it descends toward the mouth and marks the middle of the upper lip. The little concave depression in the middle of the curve of the upper line of the upper lip seems to be duplicated in the curve of the lower line of the upper lip, both curves forming the boundary to the thickness of the lip at this point. From the middle, the upper lines of the upper lip curve downwards toward the corners, while the lower lines of the upper lip follow approximately the same direction and the two meet in the depression at the corner. In direct front view, the degrees of convexity and concavity in the form of the lips are expressed by the intensity and shape of the shadow, Fig. 45.

51. Foreshortened Views.—In various foreshortened positions in which the mouth is frequently seen, the lips assume many changes in appearance. It is plain that when observed from a low point of view, the upper lip will appear at its full thickness, Fig. 47, and the lower lip will appear thinner than when seen level with the eye of the observer. When

seen from above, Fig. 48, the lower lip will exhibit its full thickness and the upper lip will appear thinner than when seen on a level with the eye.

In the three-quarter view, Fig. 49, the nearer side of the mouth from the middle to the corner is seen in its full dimension, losing nothing by foreshortening; the other side, however,

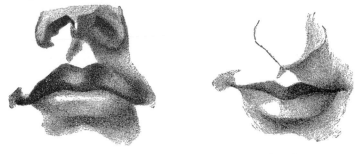

FIG. 47 FIG. 48

appears much shorter, and in some cases the space between the middle and the farther corner will be lost entirely. A three-quarter view of the mouth from below, Fig. 50, is influenced by foreshortening from two quarters, the point being to the side as

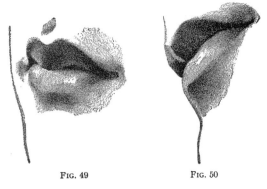

FIG. 49 FIG. 50

well as below. The curves from this position, as well as a three-quarter view from above, should be carefully studied.

The mouth and eyes combine to give various expressions to the face. When the lips are parted slightly, as in Fig. 51, the teeth show within and a half-smiling expression is given

this feature by slightly raising the corner. In front and three-quarter views, the lips lengthen and flatten out in the act of smiling, as shown in Fig. 52. In Fig. 53 is shown the outline construction of the mouth illustrated in the previous figure.

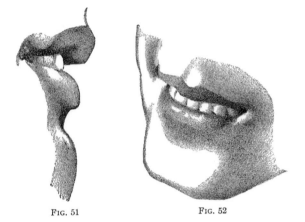

Fig. 51 Fig. 52

Note the foreshortened profile line through the center of the lips and chin. This line is identical with the profile of the nose, lips, and chin shown in Fig. 42, except that the lips are parted.

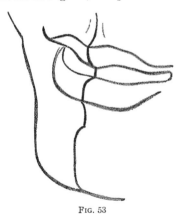

Fig. 53

If care is taken always to draw this foreshortened profile line, as shown in Figs. 42 and 53, the accuracy of profile and three-quarter-view drawings of the face will be assured.

52. Viewed in profile, with the eye of the beholder on a level with the ear of the model, the top of the ear will be about on a level with the eyebrow and the bottom of the ear will be nearly on the same line as the base of the nose, although this detail varies in individuals. The ear occupies a position somewhat back of the center of the head, and in the classic figure the top of the ear rests on a line midway between the top of the head and the bottom of the jaw. The general direction of the ear is slightly at an angle, the line from its center pointing slightly toward the chin, as shown in Fig. 54. The form of the ear is decidedly unconventional, and must be studied carefully

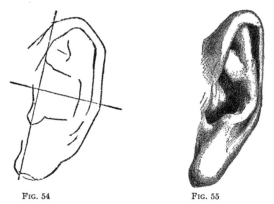

FIG. 54 FIG. 55

to be well understood. In its numerous concavities and convexities various shadows are cast, in the location of which lies the secret of rendering it properly. These shadows indicate every winding recess of the bowl and every prominence and hollow in the brim. In the front, or three-quarter view, Fig. 55, the lobe of the ear is closely attached to the head, but the upper part is much less so, as is readily seen when the ear is viewed from behind, as in Fig. 56. In Fig. 57 the ear is shown in full side view or as it appears when the head is in profile. The distinguishing characteristics of this feature should be located and their differences in the persons that are seen in every-day life noted.

The ear is very intricate in its formation, and in the fore-shortening of the head the proper placing of this feature is of the utmost importance. As said before, a line through the

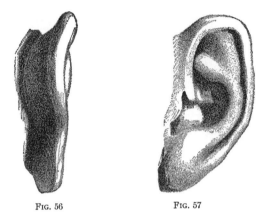

FIG. 56 FIG. 57

head from one ear to the other forms an axis, so that the placing of the ear is a sort of key to the action of the head.

THE CHIN

53. The bottom of the chin is about one-third the length of the face below the nose when in profile. The back part of the head at its lowest extremity is about on a level with a horizontal line drawn across the head at the base of the nose. Therefore, the front of the head bears a proportion of three parts to two when compared with the length of the back of the head, and this extra third portion includes the mouth and chin.

Where the head is thrown well back, the back portion of the head is lowered and the chin raised, and great care must be exercised in order that their proper relative positions are preserved. When observed from below, the chin is more in the foreground than any other part of the face; but when observed from above, the chin is more in the background than any other portion of the face. Observance of these effects is of the utmost importance in the rendering of these details.

FIGURE DRAWING EXERCISES

GENERAL INFORMATION

54. Tests in Figure Proportioning.—Reference has already been made to the three stages in which figure drawing is being taught; first, text and illustrations to acquaint the beginner with the typical proportions of human figures, the system of blocking them in, and the detailed modeling of various parts; second, the actual drawing of human figures in repose; and third, the drawing of figures in action.

So far, the first stage of this three-fold training has been covered. It is now necessary that the drawings be submitted by the student to demonstrate to his instructors that he understands the figure proportions discussed in the text.

As in previous subjects, the sheets of paper (referred to as plates) containing the student's drawings are to be of uniform size, if possible 10 inches wide by 15 inches high, or $10\frac{1}{2}$ inches wide by 16 inches high, depending on the kind of paper used. The drawings called for, taken from certain illustrations in the text, are all to be so arranged that each plate may be drawn upright; that is, with the longer dimension (15 in. or 16 in.) vertical, and the shorter dimension (10 in. or $10\frac{1}{2}$ in.) horizontal.

55. Character of Drawings on Plates.—The test drawings in this subject, as already indicated, are arranged to give the student training in understanding the typical proportions of the human figure, and in the actual making of such diagrammatic drawings properly blocked in and proportioned and with proper skeleton lines. Since no detailed rendering or modeling is required here, the work can be done with the simplest materials. Any cold-pressed white drawing paper (two $10''\times15''$ sheets cut from a $15''\times20''$ "demi" size) with a toothed surface may be used. One medium-hard lead

pencil for blocking in and proportioning the figures, and a
rather soft pencil (a 2B or a 3B) for drawing the contour and
accenting lines of the figure studies, or for doing any shading
that may be desired are needed.

Should the student desire to use the pointed charcoal stick,
or an artists' crayon stick or pencil, on charcoal paper, he can
do so and obtain good results. In such a case, the sheets used
for plates will be $12\frac{1}{2}$ inches wide by 19 inches high. Such
drawings, however, must be sprayed with fixatif before they
are rolled and placed in the tubes for mailing.

PLATE 1

56. Exercise for Plate 1.—For this first plate, 10 inches
wide and 15 inches high, the student should make a careful
copy of everything in Fig. 4, including the front-face view and
the side, or profile, view of the figure, the head-height lines, the
block forms, and the lettering.

The drawing made by the student will fit well on the sheet
if each dimension in Fig. 4 (obtained by measuring it with a
foot rule) is made exactly twice as large on the drawing paper.
The resulting diagram will be twice the original size. The lay-
out may be made as follows:

The entire diagram in Fig. 4 is approximately $5\frac{1}{2}$ inches high
by $3\frac{3}{4}$ inches (a bit less) wide. Double these dimensions,
making the layout for the diagram 11 inches high by $7\frac{1}{2}$ inches
wide. Draw a horizontal line 2 inches below the top edge, and
another horizontal line 2 inches above the lower edge of the
$10''\times15''$ sheet. Then draw a vertical line $1\frac{1}{4}$ inches from
the left edge, and another vertical line $1\frac{1}{4}$ inches from the
right edge of the $10''\times15''$ sheet. This will form a $7\frac{1}{2}''\times11''$
rectangle. Now draw a horizontal line $1\frac{1}{2}$ inches below the
top edge of the rectangle to locate the crowns of the heads of
the figures, and draw another horizontal line $1\frac{1}{2}$ inches above
the bottom edge of the rectangle to locate the approximate
line on which the feet of the figures are placed—the bottom
dotted line in the diagram. Thus a space exactly 8 inches high
will be laid out.

In the illustration in Fig. 4, the dotted vertical lines showing the head heights are $\frac{1}{2}$ inch apart, because there the figures are 4 inches tall. In the diagram the student draws on his plate, which is double the size of the diagram in the text, the figures are 8 inches tall, and thus each head-height (the distance between the horizontal dotted lines) is 1 inch.

The approximate positions of the blocks (each 1 inch square) and double blocks can be indicated by drawing a short horizontal line 1 inch below the top line, and another one 1 inch above the bottom line, of the main rectangle. The widths and placing of these blocks will be discussed as the horizontal, or side, measurements are described.

57. To determine the horizontal, or side, measurements, draw a vertical line about 4 inches to the left of the right-hand vertical edge of the large rectangle; and, making each one of the tall pile of eight blocks, or "heads," in the center of the diagram 1 inch wide and 1 inch high, sketch them in freehand. Then the width of each one of the four spaces shown by vertical dotted lines in the left-hand section of the diagram, will be $\frac{5}{8}$ inch.

The blocks at top and bottom of this left-hand section can next be sketched in freehand on a vertical center line of the full front figure. A similar procedure is followed for the head-heights and head-widths of the profile figure in the right-hand portion of the diagram.

There now remains the important task of sketching in freehand, with a soft pencil, the full-face figure and the profile figure upon the diagram constructed. Use bold lines, not hard, sharp, and "wiry" ones. If desired, charcoal or crayon, on charcoal paper $12\frac{1}{2}$ inches wide by 19 inches high, may be used, if proper modifications of marginal dimensions are made.

Again the reminder must be given that the drawing just made for this Plate 1: The Human Figure, will be exactly twice the size shown in Fig. 4 of the text.

58. Final Work on Plate 1.—Letter or write at the top of the sheet, Plate 1: The Human Figure, and, on the back of

the sheet, the class letters and number, name, address, and date. Forward the plate in a mailing tube, at third-class postal rates, to the Schools for inspection and comments, and then proceed with Plate 2.

PLATE 2

59. Exercise for Plate 2.—The student has made his Plate 1 a diagrammatic layout of the proportions of the human figure, and now his work for Plate 2 will be a diagrammatic layout of the relative proportions of child, youth, and adult figures. To do the work on this plate proceed as follows:

Lay out a rectangle approximately 8 inches wide and 8 inches high on the $10'' \times 15''$ sheet. To do this, a horizontal line $3\frac{1}{2}$ inches from the bottom edge and another horizontal line $3\frac{1}{2}$ inches from the top edge of the sheet should be drawn; also, a vertical line 1 inch from the left-hand edge and another vertical line 1 inch from the right-hand edge should be drawn. An $8'' \times 8''$ rectangle will result. Should $12\frac{1}{2}'' \times 19''$ charcoal paper be used, the $10'' \times 15''$ shape may be outlined on the charcoal paper, in order to carry out the dimensions listed for a $10'' \times 15''$ sheet.

It will not be a difficult matter to divide this 8-inch rectangle into three parts which will accommodate (b), (c), and (d) of Fig. 10, page 17. If it is necessary to make the three vertical columns, in which the three figures appear, somewhat narrower in proportion than shown in Fig. 10, no harm will be done. For example, the one at the right for the adult figure may be 3 inches wide, and the other two may each be $2\frac{1}{2}$ inches high. Inasmuch as the adult figure is 8 heads in height, naturally the horizontal dividing lines, as shown in (d), when enlarged to fit into the $8'' \times 8''$ rectangle on the plate, will be 1 inch high. In other words, the adult figure in the right-hand column on the plate being drawn will be 8 heads high and actually 8 inches high, and each division, therefore, will be 1 inch high.

The horizontal lines to show the head heights of the youth of 9 years in the center and the child of 5 years at the left will

have to be laid out, freehand, in proportion to the head heights of the adult figure as previously described.

It will not be a difficult matter to draw this diagram with the dimensions just given; then the coutours of the adult figure, the youth's figure, and the child's figure can be sketched in freehand, inasmuch as the student already has a knowledge of the proportions of the heights and widths of the adult's figure, and can very well sketch in the three figures just as they appear in Fig. 10.

Particular attention is called to the fact that view (a) of Fig. 10, showing the infant of 6 months, is to be omitted, because it is not often that one would be required to draw an infant of 6 months standing erect. The student need, therefore, only draw the child's figure, the youth's figure, and the adult's figure.

As in the case of Plate 1, this drawing should be done with bold lines made with a soft pencil; a hard pencil should be avoided. If it is desired to do this work with a crayon pencil, or with the point of a charcoal stick, it may be done in that way, on charcoal paper $12\frac{1}{2}$ inches wide by 19 inches high, in which case proper modifications of margins must be made, as previously explained.

60. Final Work on Plate 2.—Letter or write at the top of the sheet, Plate 2: The Human Figure, and, on the back of the sheet, the class letters and number, name, address, and date. Forward the plate in a mailing tube, at third-class postal rates, to the Schools for inspection and comments, and then proceed with Plate 3.

<hr>

PLATE 3

61. Exercise for Plate 3.—After a certain amount of practice in laying out the proportions of the entire human figure, it is advisable to have some training in the drawing of the head. For practice, the head is first drawn in side profile, then full face, and later three-quarter profile.

First, practice laying out a large profile view of the head shown in Fig. 11. The diagram in the text is roughly $2\frac{1}{4}$

inches square or a trifle smaller. Lay out a 9″×9″ square on
a 10″×15″ sheet of paper. The simplest way to do this is to
draw one horizontal line 3 inches above the bottom edge of the
paper and another horizontal line 3 inches below the top edge
of the sheet; then draw a vertical line $\frac{1}{2}$ inch from the left-hand
edge of the sheet and another vertical line $\frac{1}{2}$ inch from the
right-hand edge. Refer to remarks previously made as to
marginal dimensions if a $12\frac{1}{2}″×19″$ sheet of charcoal paper is
used.

Having established this 9″×9″ square, draw the horizontal
lines through the square, the first one $1\frac{1}{2}$ inches from the top
of the square, forming the hair line, the second one $2\frac{1}{2}$ inches
below the hair-line horizontal line, which will form the line of
the eyebrows, the third one $2\frac{1}{2}$ inches below the line of the eye-
brows, which will locate the bottom of the nose. In other
words, of the four horizontal divisions thus formed, the one at
the top is fairly narrow, $1\frac{1}{2}$ inches high, whereas the remaining
space is divided into three horizontal sections, each $2\frac{1}{2}$ inches
high.

If the student feels it necessary, he can divide the lowest
division; that is, from the bottom of the nose to the bottom of
the chin, into four additional parts, each $\frac{5}{8}$ inch in height,
which will locate the outer contour of the upper lip and the
outer contour of the lower lip, and will help to locate the exten-
sion of the chin. With these structural lines or framework
drawn, no difficulty should be experienced in blocking in
accurately the side profile of the head as shown in Fig. 11, as
training has already been given in freehand drawing. It
would be a good idea to shade the profile somewhat with pencil
lines, inasmuch as doing so will add to the practice already had
in rendering drawings in light and shade. If done in charcoal
or crayon on $12\frac{1}{2}″×19″$ sheets of charcoal paper, the margins
will be slightly wider. This is the only drawing to be made
for Plate 3, but a distinct advantage lies in additional practice
in drawing the head in other positions, using ellipses instead of
straight lines to establish the various horizontal planes as
indicated in Fig. 12. Drawing the head within properly
foreshortened "solids" is excellent practice. It is understood,

of course, that this extra work is NOT to be sent to the schools. Send only the profile view of the head for Plate 3.

62. Final Work on Plate 3.—Letter or write at the top of the sheet, Plate 3: The Human Figure, and, on the back of the sheet, the class letters and number, name, address, and date. Forward the plate in a mailing tube, at third-class postal rates, to the Schools for inspection and comments, and then proceed with Plate 4.

PLATE 4

63. Exercise for Plate 4.—As a preparation for the work that will be required in the next subject, drawings from the figure in repose, a copy of the illustration shown in the frontispiece facing page 1 of the text of this instruction paper is now to be prepared.

As explained in the text directions, this is a blocking-in drawing made from a photograph of the well-known statue, "The Crocus," and shows the proportions of the human figure very well indeed. Not only are the skeleton lines used here, but also the method of blocking in the general contour of the entire figure and the horizontal lines to show head heights.

Making this drawing will be simple, because it may be made exactly twice the size of the illustration shown in the frontispiece. The figure will thus be about 12 inches in height. The first step is to draw a center line through the $10'' \times 15''$ sheet and then to lay off the 12 inches in height on this center line, with the bottom horizontal line $1\frac{1}{2}$ inches above the lower edge of the sheet and the upper horizontal line $1\frac{1}{2}$ inches below the top edge. This idealized female figure is made eight heads in height, but, as will be learned later, female figures sketched from the living model will be considered as being only seven heads high for the purpose of the training given in this subject.

No further directions as to the drawing of diagrams are required here, because so far there has been ample practice in making diagrams in which the contours of the figure are sketched freehand.

The student can now draw, in soft pencil, in charcoal, or in crayon, a reproduction of the illustration shown in the frontispiece. If done on a $12\frac{1}{2}''\times 19''$ sheet of charcoal paper, wider margins will have to be arranged as previously explained. This rendering may be done on toned paper if the student so desires, but white paper such as that used for Plates 1, 2, and 3 will be satisfactory for Plate 4.

64. Final Work on Plate 4.—Letter or write at the top of the sheet, Plate 4: The Human Figure, and on the back of the sheet the class letters and number, name, address, and title. Forward the plate in a mailing tube, at third-class postal rate, to the Schools for inspection and comments.

If any redrawn work on any of the plates of this subject has been called for and has not yet been completed, it should be finished at this time before going on to the next subject.

65. Next Work To Be Taken Up.—By this time the one who is receiving the training in pictorial work has had a thorough drill in the making of drawings of still-life objects and in the proportions of the human figure. He is therefore ready to make drawings of the figure in repose, and, later, drawings of the figure in action. The next work to be taken up is drawing the figure in repose.

THE FIGURE IN REPOSE

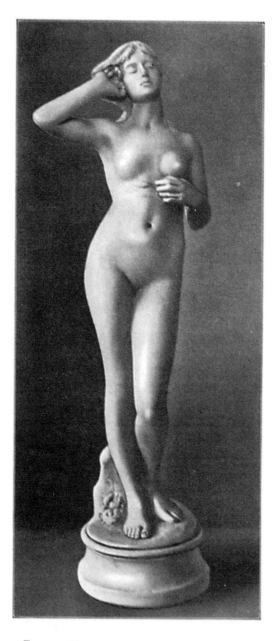

From a Photograph of a Statue, of Classic
Proportions, of the Human Figure in Repose.

THE FIGURE IN REPOSE

REPOSE

1. Characteristics of the Figure in Repose.—When one has become familiar with the proportions and structure of the human figure he is ready to make drawings from it.

Naturally, it is a simpler matter to draw a figure that is in repose than to draw one that is in action. A figure may be said to be in repose when it is standing, as, for example, at a window and looking out, or seated in a chair, perhaps, reading a newspaper, and where foreshortening need not be considered to any great degree.

Usually, a figure in repose is well balanced about the central line of support, and the center of gravity is not particularly disturbed.

2. Various Systems of Training in Figure Drawing.—Various systems of figure drawing are used by individual teachers, or are treated in books on the subject. Just which system is best suited for any individual student must be determined by the purpose for which he is studying figure drawing, and the eventual use to which he wants to put his training. There is, for example, the system of requiring the student to become familiar with the names of all the bones in the human skeleton, and with all the muscles and tendons with which these bones are clothed; and then requiring him to draw such a skeleton and clothe it with the proper muscles.

This is really a scientific study of anatomy and will be worth while only for those who intend to specialize in portraiture, or perhaps to prepare drawings exclusively for illustrating

athletic pursuits. The general pictorial artist, who needs to introduce figures into his composition pictures for advertisements, cover designs, newspaper and magazine illustrations, etc., does not need such extended anatomical training.

At the other extreme there is the school of figure drawing that bases all figure contouring on appropriate sweeping concave or convex curves, or combinations of such curves, which may be termed a free method of portraying the figure. Such a system is hardly a sufficiently thorough training for those who are learning to do practical commercial art work, and advertisement or fiction illustrating.

These various systems are referred to so that one who wants to have a thorough training in drawing the human figure to include in composition illustrations, will understand just what he must learn to do. There are many persons, ranging all the way from school children to business men, who take lessons in still-life and figure drawing, simply for the purpose of a pleasant esthetic pursuit. This is very commendable; but a more serious system is required to train the student to do figure work for practical illustrating. That is why it is necessary to offer this explanation here.

3. An experience of many years in giving training in figure drawing by the home study method has demonstrated that the most effective method for students who are to do practical commercial art work is: first, a thorough training in the proportions of the human figure and the detailing of its parts; second, training in drawing the human figure in repose, including the preliminary drawing from plaster casts of the figure, drawing from other charcoal studies and pictures, and then making drawings from the living posed model; and third, training in drawing the human figure in action from other studies and photographs and from the actual living models.

This last method is the one that will be used in the figure drawing subjects. The first step in the drawing of the figure in repose will be the preparation of drawings from plaster casts of the figure and its parts.

DRAWING FROM CASTS

4. Function of Plaster Casts.—The beginner so far may have become familiar with the height and width of the human figure, but the detailed modeling or rotundity will have been left largely to the imagination. Plaster casts of the figure and its parts are therefore used to enable the art student to see and feel the effects of roundness and solidity. A knowledge of these effects will not only aid one who is drawing the figure in repose and to render it so as to depict the life-like appearance of the human figure, but this knowledge will also help him to appreciate the positions of the parts of the figure and the change that each part undergoes when the figure is in action.

5. Suggestions for Practice Work.—The plaster casts that will be described and from which studies will be made, are: a full length cast or statuette of the female figure in fully modeled form, and almost life-size casts of the head, the hand, and the foot. As in the case of preceding studies, it is expected that drawings and renderings will be made from these plaster casts as their descriptions are being read, but these drawings are only for practice work and are not to be sent to the Schools for inspection and advice. The only drawings from the casts that are to be sent to the Schools are those which will be described under the general head, Figure Drawing Exercises, in the latter part of this instruction paper.

When these plaster casts are being inspected, they should be so placed on a table or hung against a wall, or other surface, as to be conventionally lighted; that is, with the light coming from a point at the upper left and slightly in front of the casts. The practice drawings are to be made with the materials and by the methods that will be described at the proper place.

Both charcoal and soft pencil will be suggested. However, no student should refuse to use charcoal as a medium simply because it is new to him. He will be greatly benefited by learning its use at this time.

CAST OF HEAD

6. Full Front View.—The cast of the block form of the head is needed so that practice may be had in drawing the entire head, face, and individual features approximately full size. In this way a familiarity with the placing, the proportions, and the foreshortening of these features can be acquired, and they can be drawn readily whenever it is necessary to draw the full figure. The description of the proportions and contours, as well as of the planes of light and shade, of this block form of head, and the directions for making drawings from this cast, must be somewhat detailed on account of the importance of the treatment of the human head and the face in doing illustrating work.

7. When drawing it, the cast should be hung in a good light so that the shadows will fall below and toward the right side as shown in Fig. 1. If it is hung near a window, the lower part of the window should be shaded slightly and the drawing table placed with the window to the left and the cast in front of the worker and not more than 6 or 8 feet away, so that, when the arm is extended to get the pencil measurements, the full length of the head from the crown to the chin will measure approximately $3\frac{1}{2}$ inches. The width at its widest portion will then be about $2\frac{3}{4}$ inches. These measurements should then be doubled so that the drawing of the head will, by pencil measurement, be about 7 inches high. The proportions should be determined by pencil measurements and the measurements here given should not be adhered to unless the proportions by pencil measurement vary so greatly that the block drawings cannot be contained within the confines of the drawing sheet. In this case, the drawing table should be moved farther away, so that the head may be drawn within the limits suggested.

8. Proportions of Head.—Although all proportions should be laid off by pencil measurement, it is well that the general proportions of the features to the rest of the face should be understood. In the first place, from the chin to the roots

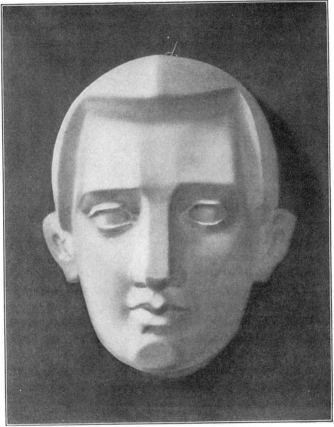

Fig. 1

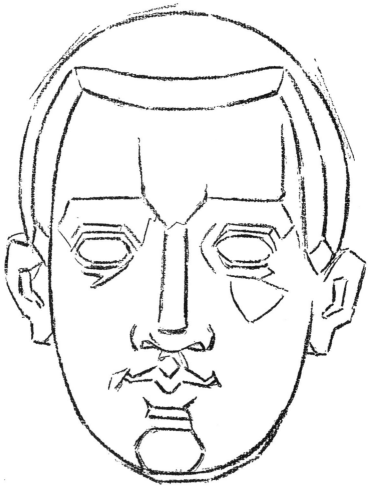

Fig. 2

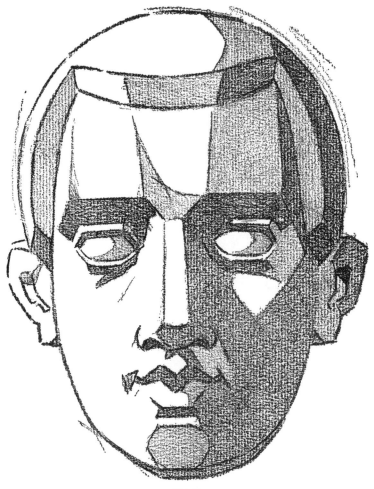

FIG. 3

of the hair is four-fifths the height of the entire head. Therefore, in the present case, should the drawing of the entire head be 7 inches in height, it will be a little more than 5½ inches from the chin to the roots of the hair. The face from the roots of the hair to the chin may be divided approximately into three equal parts, the uppermost marking the lines of the eyebrows, the next the end of the nose, and the last the chin. The entire width of the head may be divided into five equal parts, each part being equal to the width of one of the eyes, and the space between the eyes, and the spaces on each side, each being equal to the width of the eye.

The general lines of this block form of head in full-front view should first be laid in, after the usual proportioning and blocking in, as shown in Fig. 2. The general outline given to the eyes is in the proportion previously explained, the eyebrows being flattened and more angular toward the outside edges in the block form than in the free rendering. The indentation

Fig. 4

from the line of the eyebrows to the top of the nose casts a small shadow, and this should be carefully outlined, while two nearly straight lines mark the sides of the nose down the center of the face. The end of the nose is broader than the middle, or bridge, and the two side lobes, where the nose itself enters the cheeks, extend on each side and mark the broadest part of the nose. The mouth should then be outlined, great care being taken that it is properly proportioned, as can be determined by pencil measurement; and the line under the lower lip marking the indentation of the chin so located that it would form, if continued, a slightly flattened circle where it joins the under curve of the chin.

9. By closing the eyes slightly, so that the cast can be observed between the eyelashes, a great contrast between the lights and shades of the cast will be observed, and the forms of the shadows caused by the various features can be outlined, as shown in Fig. 2 and the shaded surfaces rendered

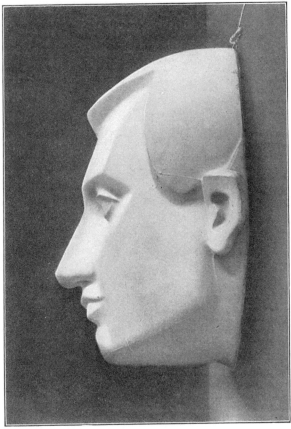

Fig. 5

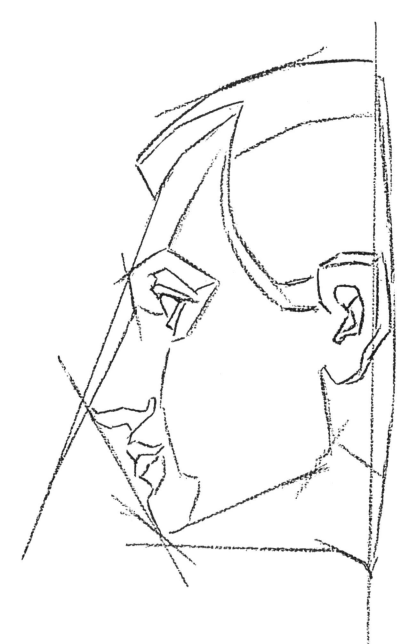

FIG. 6

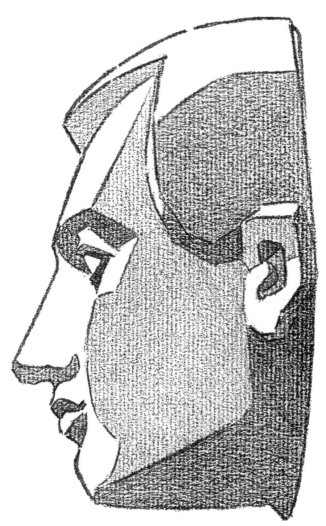

FIG. 7

as shown in Fig. 3, although they may appear to be more varied, as shown in Fig. 1. However, it is better at present to render all values in an even tone and leave the gradation of tones until later. If the cast is hung somewhat above the eye, the line marking the roots of the hair will be almost straight, but, if nearly on a level with the eye, this line will curve upward. Slightly curved lines mark the hair on the sides where it rounds down to the tops of the ears. The ear extends from the line of the eye to the bottom of the nose, and in the full front view appears somewhat as shown in Fig. 4. In shading the various flat surfaces of which this cast is composed, it is important that an even tint should represent each part of them. Softness and detail are not desired in this drawing, as a simple block representation is all that is required.

10. Profile View.—A second position in which to study the cast of the head is in profile, as shown in Figs. 5, 6, and 7. When drawing the cast in the position shown in Fig. 5, a line should first be drawn approximately representing the angle of the forehead, as shown in Fig. 6, and the relation of the line

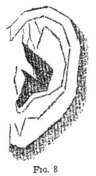

FIG. 8

of the nose to this construction line should be carefully studied. Another line from the end of the nose, touching the chin, should be carefully drawn, the angle being studied from the cast itself. The outline of the profile should now be carefully sketched and the edges of the shadows indicated thereon, while the eye and mouth are carefully rendered in accordance with the suggestions made. The ear in this drawing will appear more as shown in Fig. 8, but the back part and inside will be the only parts that are in strong shadow. The line of the hair at the forehead will curve upward or be straight, as in the previous case, according to the position of the cast, but the line should curve out toward the temple and fall slightly below the top of the ear at the side. The shaded drawing of this profile view will appear as in Fig. 7, where the planes are sharply out-

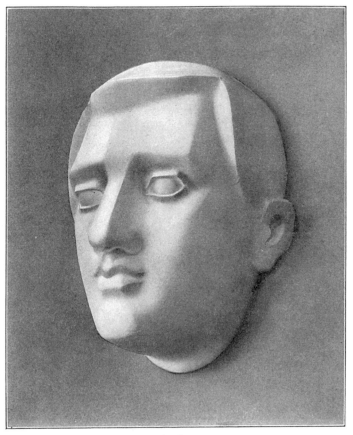

Fig. 9

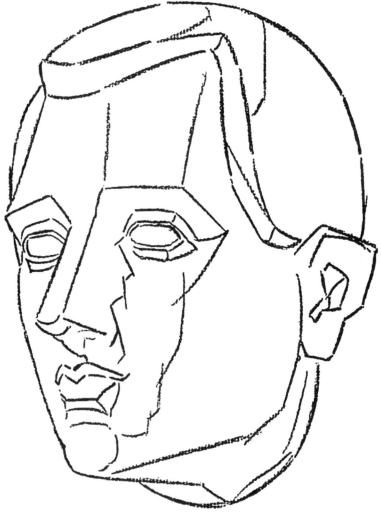

FIG. 10

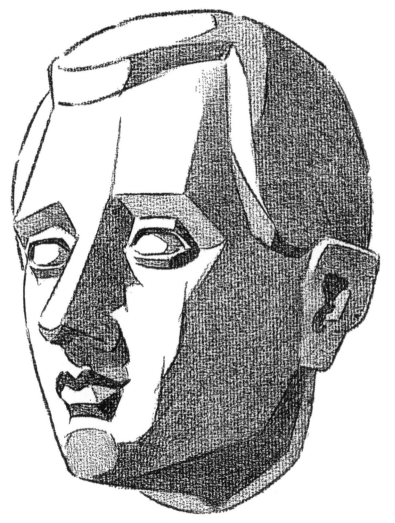

FIG. 11

lined. The planes are not so clearly defined and the cast must be studied for these lines of limitation.

11. Three-Quarter View.—The third and last position is the most difficult of these three studies, and will vary from the illustrations given in the text in connection with it, according to the amount the cast is turned from the last position. It should be hung, as shown in Fig. 9, so that rather more of the full face than the profile is seen, and the best guide is to turn it away from full face so that the corner of the farther side of the mouth is not quite visible. This will bring the mouth in the cast, and one eye, in the position previously illustrated. The line of the forehead will not now be continuous down the bridge of the nose, but will reach to the outer visible extremity of one of the eyebrows, and a portion of the eyelids of that eye will appear. All the features possess the foreshortened aspect, and each should be carefully studied before attempting to outline it on the drawing sheet. First draw the outlines of the planes of shadow, as shown in Fig. 10, and then work in the even tones that represent these planes, as shown in Fig. 11.

When working on this figure, each feature should be considered for a while as a separate problem in itself. Sometimes it will be found desirable to make separate studies of the eye, nose, and mouth before attempting to draw same in the face, but when thoroughly understood there should be no hesitation to draw them in with bold lines, making pencil measurements wherever necessary to locate the features. Also, from time to time, the drawing should be compared with the cast, to see that the renderings approach as closely as possible to the form. The outline of the shadows should not be attempted until all the features are properly in place; then the shades may be rendered lightly in an even tint, to finish the study. There is nothing extremely difficult about the rendering of this position, if the two previous ones have been carefully studied and executed. The full-face, and profile, views of the cast may also be so placed that they are below (or above) the eye-level line of the observer, showing a large portion of the top of the head (or the under side of the chin, cheek, etc.) as the case may be.

CAST OF HAND

12. Next in importance to a detailed study of the head and face is the necessity for being familiar with the life-size hand and its detailed modeling. The cast that is provided was made from an impression taken from the hand of the living model

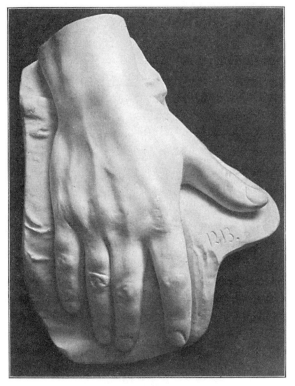

Fig. 12

and not from the hand of a statue, which makes a study of this cast, with all its detailed modeling, extremely valuable.

When it is being studied, the cast should be stood or hung vertically, and conventionally lighted, as shown in Fig. 12. The system of measuring and proportioning with pencil and plumbline (as used in the studies of the head) and then doubling the

dimensions secured may be used, or, the full-size dimensions may be laid off at once on the drawing sheet. In this case the height from extreme tip of middle finger to limit of wrist line will be 10 inches, and the extreme width from the side of the little finger to the tip of the thumb will be 7 inches. When

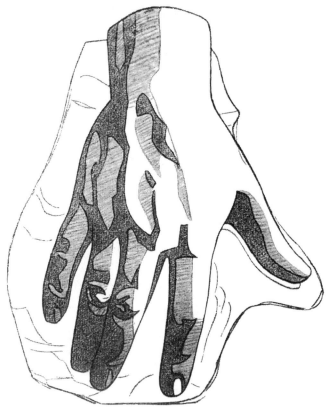

Fig. 13

drawing this cast, if desired, the supporting slab need not be shown; this is placed on the cast simply to prevent the out-stretched fingers from breaking off. It will be sufficient simply to draw and render the hand itself and put in a tinted back-

ground and arrange to have the shadows of the thumb and
fingers fall upon this tinted background just as they fall upon
the plaster supporting slab.

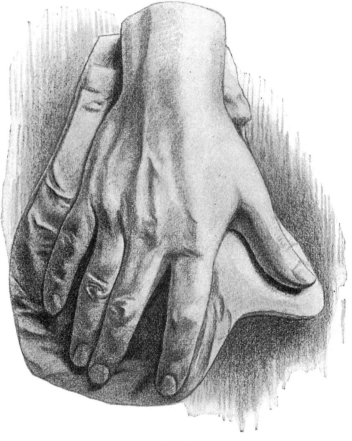

FIG. 14

13. When proportioning and blocking-in the parts of the
cast, curved guide lines may be drawn to locate the positions
of the points of the fingers, middle joints, and knuckles. Then
the main curves of the wrist and of the fingers may be drawn in,
and all the fingers and the extended thumb drawn carefully in

outline. Special care must be taken to get the contours properly drawn where the inside of the thumb joins the hand and first finger. Before proceeding with the blocking-in of the shaded values, the contour drawing should be carefully compared with the cast and any necessary corrections made.

The system of blocking-in shade values has already been explained fully. If the cast is looked at with half-closed eyes, it will at once be noticed where the deepest shadows and shade values fall, namely, in the hollow of the thumb and side of hand, on the sides of the fingers, and in the little valleys or channels on the back of the hand caused by the tendons and muscles running to the fingers. These require particularly careful observation. When the main shadows and shade values have been blocked in, the subordinate ones may be indicated as they appear next to the high lights. The blocking-in and rendering of the shade values on the drawing will appear as shown in Fig. 13.

The process of blending the blocks of shade so as to make a finished drawing is by this time a familiar one, and the rendering should now be completed as indicated in Fig. 14. While it is not expected that the rendering of this cast shall be done with such fidelity of modeling that every little ridge and every depression is shown, yet the rendering should be sufficiently complete to show the general modeling of the wrist, hand, fingers, and thumb, and the surface modeling, so as to portray a typical hand.

It will be observed from the illustrations shown in Figs. 12, 13, and 14 that only the back of the hand, with the thumb and the fingers, is shown. Naturally, this would be the most convenient way in which to show the interesting parts of the hand. The student must understand, however, that he is to study the under side of the hand also, and the hand in side profile, three-quarter profile, etc. Having learned the general proportions of the width of the back of the hand, the thumb, and the fingers, he can, while some friend holds his hand outstretched in various positions, make a sketch from his friend's hand at the same scale as that of the sketch made from the cast. It would not be possible to obtain casts of the hand in all the various positions in

which the hand might be placed, and, for that reason, the use of a living model is preferable.

The suggestions given for making sketches from hands in various positions may be applied also to the making of the sketches of feet in various positions.

CAST OF FOOT

14. In illustrating work, even when drawing from life, there will be fewer occasions to render the naked foot than

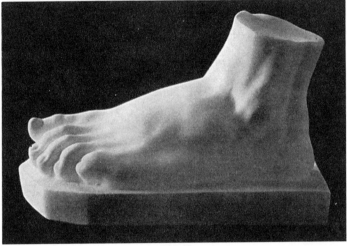

Fig. 15

the hand. It is necessary, however, to be familiar with the shape and characteristics of this detail, so as to appreciate the form better when rendering feet enclosed in shoes or sandals, as is more often the case.

When drawing the foot in its first block form, as shown in Fig. 16, the cast as illustrated in Fig. 15 should be placed slightly below the eye, at such a distance that the pencil measurement will make it about 4½ inches long, which can be doubled to 9 inches if desired. The height and the base on which the foot rests should then be located. If desired, the dimensions for the cast of the foot may be taken direct from the cast.

The ankle, instep, and heel should be indicated by a few bold lines, greater care being used to outline the subtle curves from the height of the instep to the point of the great toe. The positions of the other toes, relative to the block on which the foot rests, should then be indicated by a series of small curves, as shown at *a*, *b*, *c*, and *d*, Fig. 17, and the outlines of the toes then drawn carefully to where they join the top of the foot. The outlines of the shadows should be indicated as shown in Fig. 16, and all the shaded surfaces rendered in an even tone to express the dark side of the cast.

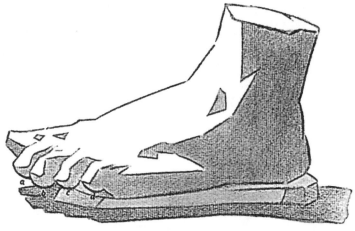

Fig. 16

15. When finishing up this rendering, great care should be given to the outlining of the front of the ankle and the top of the foot. The straight, bold lines that in Fig. 16 characterize the work may be subdued into gentle curves, but these curves should be studied carefully in the cast. It will soon be seen that the sweep from *a* to *b* in Fig. 17 is not an even, unchanging curve, but a combination of curves, and that at the point *c* it is nearly flat and, in contrast with the other curves, appears almost convex. At *b* and *d* it comes into fulness again, and at *e* is again slightly depressed.

CAST OF FULL-LENGTH FIGURE

16. Full Front View.—The first cast of the four to be
studied is the cast of the somewhat idealized full-length female
figure. In the practice work, a full-front drawing should be
made the size of the statuette, or about 12 inches high. To make
this drawing, it is first necessary to arrange the cast properly
on the table, as shown in the frontispiece facing page 1, and to
place proportioning lines. After that, the necessary block-

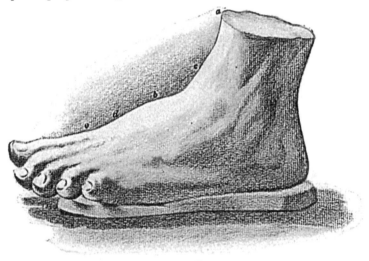

Fig. 17

ing-in lines should be drawn and then the main curves of the
figure placed and elaborated. The drawing is then ready for
plotting and shading in the blocks of shade values seen on the
cast; these values are contoured and shaded in the same manner
as were the shade values of the study of the other casts pre-
viously rendered.

In Fig. 18 is shown how the blocks of shade values will appear
when the cast is seen in full front view, as shown in the frontis-
piece. It will be observed that the darkest shade values are
on the neck under the chin, on the figure's left side, in the
hollows where the legs join the abdomen, along the inside of

the right leg, and on the lower legs. There should be no diffi-
culty in seeing these planes of shade values, and in blocking
them in, if the contouring outlines of these blocks of shade are
first carefully drawn. When blending these blocks of shade
values the procedure previously described should be followed.

17. More can be learned by studying one's drawings for
faults and defects than by confining one's attention to reading
the text for specific instructions. A person must learn to draw
what he sees and to determine if his own drawing represents
what he sees, or if it does not, wherein it fails. To do this, he
must work slowly from point to point, erasing as little as pos-
sible, keeping the charcoal sharp enough so that the lines may
be placed exactly where required, but by no means as sharp
as is required for ordinary pencil drawing. Charcoal rendering
aims to secure broad effects, and in the blocking in of planes
of shade values nothing should be represented but a series of
flat planes that join each other to make up the characteristics of
the human form. When their position and form is once under-
stood, these planes may be easily varied and softened into one
another so that the general softness and characteristics of the
individual figure can be represented in close portrayal, or, if it
is the face that is being drawn, in exaggerated portrayal, as in
caricature work. It is important that the flat, plain surfaces of
the forms be well understood before the subtle curvatures of a
finished form are attempted.

18. Profile and Three-Quarter Views.—Studies from
this cast of the female figure in other positions should be made,
as, for instance, side views (that is, right profile and left
profile), three-quarter views, first one side then the other, and
a rear view, proceeding with the drawing and rendering in the
five stages as previously described. The drawing, and the
arrangement of the blocks of shade values on these profile, three-
quarter and rear views will be different from those shown in
Fig. 18, but the practice in making these drawings of various
views of the figure will make one very familiar with the model-
ing of the human figure and its parts and will serve as a
preparation for the work of drawing from the living model.

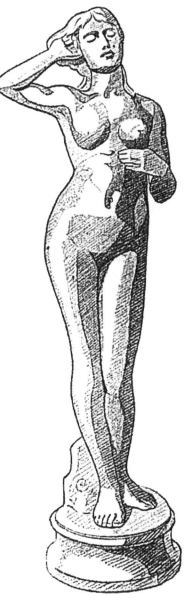

Fig. 18

19. Purpose of Using Example of Plaster Cast of Full Figure.—We use as an example of the full figure a reproduction in the form of a plaster cast of the very fine statue of The Crocus, sometimes called the Snow Drop, by the famous sculptor John Borgeson, to show the proportions of the ideal human figure. From it the student is able to get a better idea of the general proportions of the average figure than he would get if we were to show photographs of some individual model. The models who pose for life classes in art schools differ greatly in their proportions and, when one gets the proportions of one model who posed, these same proportions might not apply to another model. However, sculptors who portray the human figure, especially in symbolic form, generally use what may be termed a composite arrangement of the proportions of the human figure. These proportions are particularly well indicated in the cast which has been photographed for the halftone illustration shown in the frontispiece opposite page 1. Should anyone who is working on this course desire to have photographs of living models it would be a simple matter for him to pick up magazines containing such figure studies in any book store, or on any news-stand; or find out, from the proprietor of the book store or news-stand, where other magazines containing photographs of the human figure can be obtained.

In blocking in any figure, whether it is an idealized figure taken from a plaster cast or whether one is blocking in the head heights of a figure that is sketched direct from the living model, it must be remembered that the various divisions of eight heads in height for the male figure, and seven heads for the female figure, will not always come exactly at the places indicated. Sometimes a model has very long legs and a short torso. Sometimes the head is small as compared with the total height of the figure. Sometimes, especially in the case of the female figure, the head may be of such a size that the figure itself is only seven heads in height (see Figs. 19 to 23). This point must be borne in mind by anyone who is making drawings from the actual model. The proportion of eight heads in height is really what is known as the classic proportion taken from some of the

classic statues. In certain instances the female figure, particularly, is rather short as compared with the size of the head, and frequently such a figure will need to be proportioned at only seven heads in height. However, these adaptations of the classic proportions, eight heads in height for the male figure, and seven heads in height for the female figure, may safely be used by the student when making his drawings in this subject. There are occasions, especially in decorative work, where figures are seen from such a great distance below that a proportion of eight and one-half or nine heads in height may be used. This, of course, applies only to decorative work, or perhaps mural paintings. If there is a frieze of figures around the top of a large rotunda or auditorium, perhaps 18 or 20 feet above the level of the floor, naturally these figures would have to be drawn larger than if they were seen at eye level, because there is sharp foreshortening when the observer looks up at these figures, and, unless they were drawn much taller than the normal proportions, they would appear short and stunted in appearance when seen from below.

The foregoing explanations are given so that the student will understand that when we speak of the male figure being eight heads in height we are giving the classic proportions; and the young artist himself is expected to adapt these classic proportions to the particular model from which he is making the drawing, and to the purpose for which the drawing or painting of the human figure is being made.

It must be remembered that the general proportions given here are to serve only as guides. By this time the one who is being trained in pictorial work will have learned that, irrespective of proportions, head heights, etc., he must draw and render each human figure as he sees it; and then he must compare his drawing, as a whole and feature by features, with the original model or study from which his sketch was made. Finally he must make such alterations and corrections as may be required before sending in the regular drawing exercise as a plate.

DRAWING FROM CHARCOAL STUDIES

PROGRESSIVE STAGES OF DRAWING

20. Function of Charcoal Studies.—Making charcoal drawings from other charcoal studies of the human figure is one of the proper methods of drawing the figure, because these studies are graded in such a way as to show the stages of making a realistic rendering. Such drawing cannot be considered as copy work, as the term is frequently used; rather does it afford a training in the proper technique of rendering to portray the modeling of the figure, the flesh textures, etc.

21. The progressive stages by which such renderings of the figure are made, as shown in Figs. 19 to 23, inclusive, are: (1) Proportioning and blocking in the sizes and the contours of the figure; (2) placing the main curves in their simplest forms; (3) elaborating and detailing these contour curves to form the outside contour and the contour details of the parts of the figure; (4) plotting and shading in the areas of shade values such as light gray, medium gray, dark gray, etc.; (5) making the completed rendering of the entire figure so as to express modeling, textures, etc.

22. Proportioning and Blocking in the Contours. Let it be assumed that the female figure shown in Fig. 23 is a posed, living model, from which a drawing and rendering is to be made. Therefore, it will be necessary to keep in mind, but not necessarily to draw, the imaginary flexible solids in which each part of the figure may be considered as being enclosed.

The first step in the drawing of this figure is the placing of vertical, horizontal, and oblique lines to determine the sizes and proportions of the figure and its parts as illustrated in Fig. 19. The first line to be drawn is the vertical line A B, which will serve as the line of support, or the vertical median line. In this case the short line y z at the top of the figure should also be drawn, as this is the center line of the head, the head being

FIG. 19

slightly inclined toward the model's left side, that is, toward the right of the picture as one looks at it.

23. The next lines to be drawn are the horizontal lines C D and Q R for the crown of the head and the approximate position of the soles of the feet. If the $12\frac{1}{2}'' \times 19''$ sheet of paper is used, these lines should be 14 inches apart, making the female figure 14 inches tall, each head-height section being 2 inches high.

Next, the horizontal lines to locate the various parts of the figure should be drawn. Draw line E F 2 inches below C D, locating the bottom of the chin. Next, 2 inches below E F, draw horizontal line G H, which will locate the approximate position of the bottom of the breasts; then draw line I J, the horizontal line locating the upper part of the hips; next, draw line K L, the horizontal line of the mid-thigh; next, draw line M N, the line of the knees; and after that, line O P, the bottom of the calves of the legs; line Q R, the approximate position of the soles of the feet, has already been drawn.

Other horizontal lines are now to be drawn. Line S T, being midway between I J and K L, locates the bottom of the trunk, or torso. The horizontal space between C D and S T, that is, the exact upper half of the figure, may now be subdivided into three additional parts by means of the two horizontal lines U V and W X, which will locate the shoulders and the waist, respectively.

Several of these horizontal lines must be tipped because certain portions of this model are slightly foreshortened. For example, the line U V for the shoulders must be tipped so as to become line a b; and K L, the line for the knees, must be tipped so as to become line o p, because the shoulder line and any other lines are actually tipped by the model in the position that has been taken.

24. Placing Main Curves of Figure.—The next step in the drawing of the figure consists of plotting in the simplest curves or contours over the proportion and blocking-in lines used for the first step. In Fig. 20, these lines are again shown but, so as to prevent confusion, are not lettered. First, the semi-circular curve A is drawn as the general form for the top of

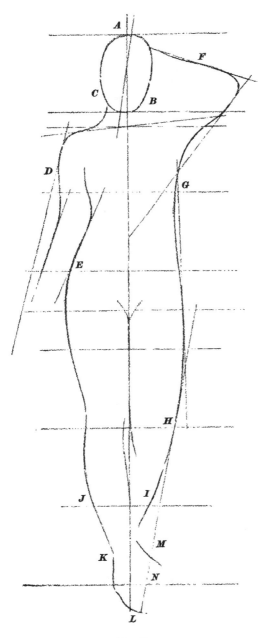

Fig. 20

the head; then curves *B* and *C* for the cheeks and chin, thus making an oval for the general shape of the head. Next, the compound curve *D* is drawn with extreme care following the blocking-in line *c d*, Fig. 19, to show the outer contour and general direction of the shoulder and the right arm; then another compound curve *E* following blocking-in lines *g h* and *i f*, Fig. 19, is drawn to express the contour of the model's right side from armpit to knee. This must be drawn very carefully, and not simply dashed off with haste. Curve *F* is then drawn to contour the uplifted left forearm following the blocking-in line; next curve *G* is drawn to show the model's left side from elbow to thigh, following the blocking-in lines *m n* and *e f*, Fig. 19. The general outside contours of the lower legs are expressed by curves *H* and *I* for the left leg, and *J* for the right leg, following blocking-in lines *k l* and *i j*, Fig. 19. The short curves *K*, *L*, *M*, and *N*, carefully placed to express the general contours of the feet, will then complete the main curves of the model.

These main curves must be freely and firmly drawn with the charcoal stick; they must not show any tendency to feel around for the proper positions. If the blocking-in lines have been carefully drawn, the curves can be placed with accuracy.

25. Elaborating and Detailing the Curves.—Fig. 21 shows the third step in drawing the figure; namely, the finishing up and detailing of the curves and contours so as to have a fairly complete outline drawing of the model, without any attempt at modeling or shading. While the final rendering of the figure is not to show detailed outlining, a great deal of such outlining must first be done in order to have accurate modeling. When the final rendering is prepared, this outlining, made of course with charcoal, will be blended into the values, as was done when renderings were made from the wooden models.

To complete this part of the drawing, the features of the face and the hair, then the hands, fingers, feet, and toes, should be drawn in outline. Then should be put in the contours of other parts of the body that were not previously expressed, such as the breasts, the navel, the completion of the curves of the lower

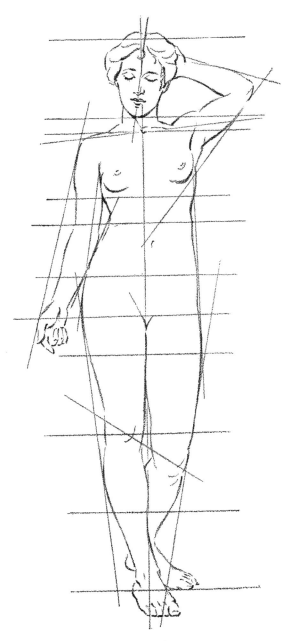

FIG. 21

part of the abdomen, and the curves of the inner and outer contours of the arms, wrists, legs, and feet. In no case, however, should these details be drawn in a vague uncertain manner. They should be drawn according to the directions and illustrations given previously, which should be constantly referred to when this work is being done.

26. For instance, when the eyes, nose, and mouth in this particular figure are to be drawn, these features should be placed in their relative positions as shown and, for their correct detailed drawing, reference must be made to the illustrations and structural drawings of these details as given in the former subject. Thus, correct drawings will be found of the eyes looking down, just about as in the case of the eyes of the model in Fig. 23. In like manner the nose, mouth, hands, fingers, feet, toes, etc., should all be drawn in with care, and only after reference to the detailed pictures of these features. If these directions are followed there will be no reason for any inaccuracy in the outline drawing of the detailed features of the face and figure.

27. Plotting and Rendering in Shade Values.—So far, the drawing of the figure has been expressed only in outline and is, therefore, only in its foundation form. Because there are no absolute outlines in nature, the figure's solidity, that is, its three dimensions of height, width, and thickness, must be expressed by means of tone values, as shown in Fig. 22. The principles governing these light-and-shade values are similar to those that govern light-and-shade values on the wooden geometric models, and can be applied readily to the human figure.

If the figure is placed in a strong light coming from one direction, the light and shade will resolve themselves into well-defined planes, while the margins of the shadows will seem to have a definite outline, darker in some places than the body of the shadow itself. The term *planes* of light and shade is used because that is the most convenient way of expressing these details.

Let is be assumed that the body is composed of a number of flat or flattened surfaces joined together to cover the general mass in the same manner as on the wooden geometric models. The blending of the shadows where these planes meet portrays

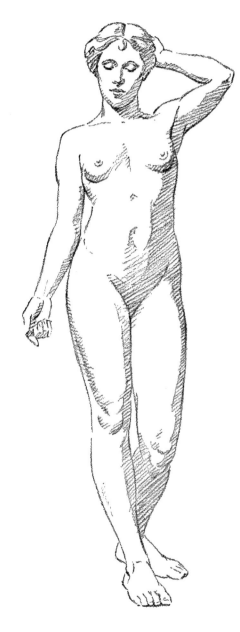

FIG. 22

the rotundity and completes the modeling of the figure. The simple effects of light-and-shade study in the geometrical wooden models are applicable here, and though the shadows may not be sharply defined they may be considered so and blended off afterward. In figure drawing, the eye must search carefully for half tones of shades in order to express them in their proper values.

28. When drawing from the figure, the first thought should be to search for the definite margins of the main shade values. Accents that are strong in some portions of the margins are lost in others, and in other places the margins of the tones appear to blend with the lights forming the half tones. Careful search, however, will disclose the fact that the half tone itself has a definite margin. Looking at the figure as a whole, different planes of tone, the full light, the half tone, and the full shade should be sought. With practice it is possible to distinguish and draw the outlines of these three tones accurately and then to lay in the tones themselves. Thus, the effect of solidity is certain, because the blending of one tone with another is a very simple matter.

When the limits of the planes of shades have been located by outlines, they should be tinted in with flat values by drawing light diagonal lines with the point of the charcoal stick, as shown in Fig. 22. If the model is looked at with partially closed eyes, these darker shade values assume distinct forms, and can be readily contoured and shaded. In this model, the very darkest shades (aside from the dark value of hair itself are noticeable on the model's left cheek and chin, on the left side of her neck, under her left arm, along her left side, in the hollow made by the rounding portions of the lower part of the abdomen where it meets the legs, along the inner side of the right leg, and on the left lower leg. These darker shades are accompanied by other distinct shades not so dark, as over the front of the abdomen, along the left side, on the arms, legs, etc. By training himself to see these shade values, preferably through half-closed eyes, one will soon become accustomed to locating them in any figure. Here again, keen observation and accurate eye measurement and proportioning are needed.

Fig. 23

29. Rendering the Figure to Express Full Modeling.—In Fig. 23 is shown the fifth and last stage of drawing the human figure. It consists of so blending the blocked-in shade values of the previous stage as to soften off their edges and make a gradual transition from the lightest values, through the semitones, to the darkest values, in all parts of the figure. When this has been done the figure will be competely rendered to show proper rounding, or modeling, of all its parts, and proper texture of flesh. The method of making a realistic charcoal drawing of the human figure is similar to that used when drawing from the wooden models.

30. To complete this drawing, search the study of the model, Fig. 23, for places in the blocked-in planes of shade where the margins of the shade values are not sharply defined, or are altogether lost. At such places, the shade values melt into the lighter tones. There will be other places where the margins are accented by a greater depth of tone and a more distinct edge. In the case of both kinds of margins, the dark values and the lighter values must be pulled together so that they blend softly. The sharp lines of the edges of the blocked-in shades may be lifted off (partially or entirely) with the kneaded eraser and, first by oblique parallel lines and then by a blending of these lines by slight rubbing, the tones may be gradually fused one into the other. The rubbing of the charcoal lines must be done very lightly, with the tip of the finger or with a piece of chamois skin, so that the charcoal lines will be blended but the surface of the paper will not be spoiled. The kneaded rubber can always be used to advantage in lightening any value that seems too dark, or for securing more brilliant high lights.

No hard-and-fast rules for rendering light-and-shade values and flesh textures can be given, for every one must find out by experiment just how to handle the charcoal to get the desired effects. However, certain general suggestions, applicable to the securing of various effects, may be of special value in the rendering of figure studies.

31. Technique of Charcoal for Figure Studies. The following points should be observed in using charcoal:

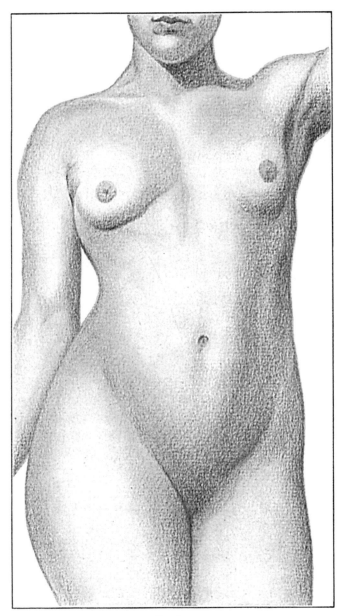

FIG. 24

1. When rendering the face, the general tint may first be placed by light oblique lines close together and afterward lightly rubbed to make a flat tint. The shaded portions of the face may be portrayed in the same way with darker strokes afterward blended. The lighter portions of the flesh tint may be rubbed off with the stomp or lifted off with the kneaded rubber. The details of the eyes, nose, mouth, etc., may be placed by means of lines made with the sharpened charcoal stick, these lines afterward being softened with the tip of the stomp.

2. Transparency of tone, to express the texture of flesh, is secured by first placing a tint over the desired portions in the usual way (lines lightly rubbed) and then, with the point of the sharpened charcoal stick, placing other lines over this ground-work tint, cross-hatched and curved, or straight, allowing the lines to show crisp and clear, and unrubbed.

3. Transparency must also be expressed even in the deepest shadows. Simply because a shade value or shadow appears to be the darkest spot in the study is no reason for making it black by rubbing the lines hard. How far it is from being absolutely black may be seen by placing next to it a piece of perfectly black cloth, cardboard, or paper, and noting how light, by comparison, is the shade or shadow value.

4. The edges of the planes of shade or shadow may be blended off softly into the lighter values by gentle touches with the end of the finger, the chamois skin, or the stomp, the deeper shadows being added later by lines and worked over as before.

5. When very small or narrow planes or values are to be expressed, as the planes to express the fingers or toes, the edges of muscles, etc., powdered charcoal can be made by scraping some from the sticks of charcoal and then applying it with the tip of a small stomp at the desired places.

6. Rubbing with the stomp should be done only when necessary; that is, on small details where the finger would be too clumsy. If the stomp is used to excess for rubbing, the paper will be spoiled, and the tone value will be hard and muddy.

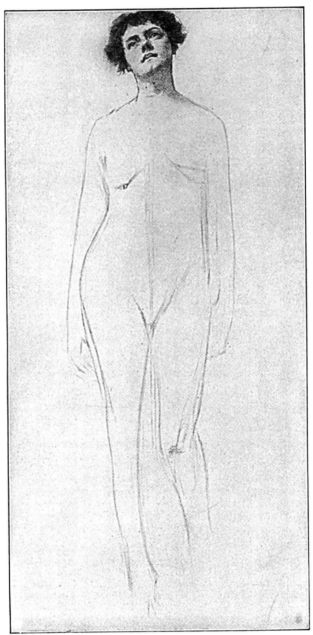

Drawn by MELVIN NICHOLS

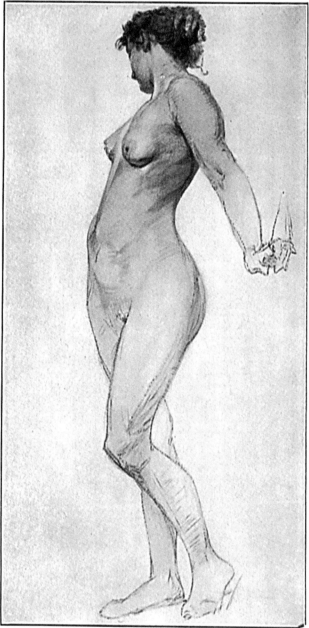

Drawn by MELVIN NICHOLS

FIG. 26

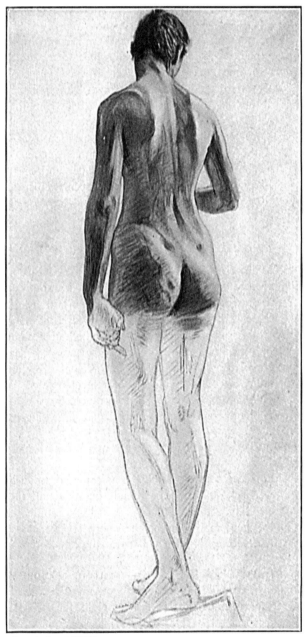

Drawn by MELVIN NICHOLS

FIG. 27

7. After most of the modeling has been secured in the manner just explained, it is perfectly allowable to accent portions by means of lines made with the sharpened charcoal stick. These must be carefully placed, however, and must be used sparingly, otherwise the roundness of the body and limbs will be destroyed.

In Fig. 24 is shown a reproduction of a portion of a charcoal drawing of the model shown in Fig. 23, made at an enlarged size so that the texture of the charcoal paper and the manner in which the charcoal is applied are plainly seen. This reproduction should be studied with extreme care.

EXAMPLES OF CHARCOAL STUDIES

32. Advantage of Studying Charcoal Renderings. The illustrations shown in Figs. 25 to 33 are reproductions of charcoal drawings made direct from male and from female models. These charcoal drawings were prepared as part of the regular work of students learning to draw the human figure, and show not only proportions and postures of various types of figures, but reveal the steps by which the student drew and rendered the figure after he had blocked in its proportions, contours, and planes of light and shade. These illustrations will reveal much more than would mere photographs of a single model.

33. Preliminary Charcoal Study of Blocking-In Lines.—The reproduction in Fig. 25 shows the entire figure lightly blocked in, and a complete rendering, or modeling, of the face and neck started before rendering in detail the other parts of the body. The manner in which the student should swing in the long main contour lines in a broad way, before starting the detailing, is clearly illustrated.

34. Study Showing Main Contours Blocked In. Fig. 26 shows a rendering fairly well contoured and more parts detailed in modeling than in the example just given. The hair, cheek, breasts, left side, etc., have been partially modeled, indicating that the study has been carried somewhat farther

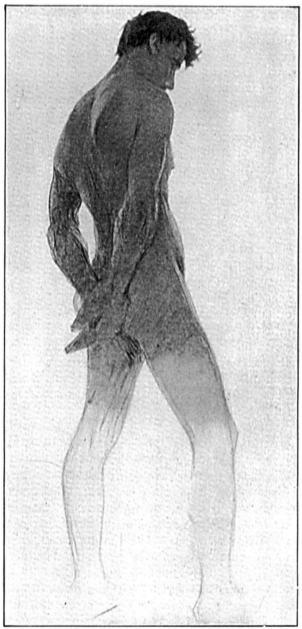

Drawn by MELVIN NICHOLS

FIG. 28

than that of Fig. 25. In this figure, the pose reveals the beautiful curve in the female back, as well as the profile of the breast and upper portions of the body.

The general direction of the right leg gives the line of support; and the relative points of prominence in this entire figure in profile may be compared with the relative points of prominence studied in connection with the other illustrations. The outside of the thigh in the left leg is slightly convex, while the corresponding line on the inside of the thigh has a tendency to be concave. The positions of the feet govern the appearance and points of prominence of the leg. In the left leg, the foot rests at an angle; but in the right leg, the foot is turned in profile and is flat on the floor, thus changing the contours accordingly. From the back of the neck to the hollow of the back is an even, graceful, convex curve; at the back it becomes concave and swells again to the thigh. The left arm, extending to the ring that is grasped by the hand, exhibits some of its muscles in prominence; here the muscles swell out to form a tangential union with the curve from the back of the neck to the back of the body. The muscles of the forearm are necessarily prominent, owing to the weight that is thrown on the wrist. The fulness of the chest is shown above the left breast, and a nearly straight line extends from the under side of the right breast to the navel.

35. Study Partially Completed in Full Modeling. Fig. 27 shows a drawing of the male figure when viewed from behind, in which the rendering is carried still farther, as the entire upper part is completely modeled. The shadows are strongly marked, showing the prominence of the shoulder blades and the relative positions of the elbow and waist line, as previously pointed out. Attention is especially called to the shadows at lower part of back.

As this figure is rather thin, the points of bony prominence are readily seen. The left elbow is clearly indicated by a plane of shade and a high light in the center of the arm, while the right elbow is brought into prominence by means of the position of the arm. The bony construction of the hips beneath

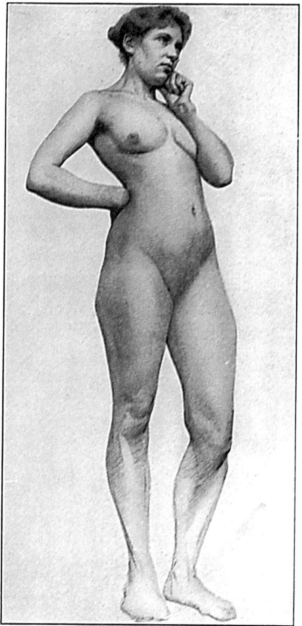

Drawn by Chas. A. Pulcifer

Fig. 29

the flesh is shown by the fulness on the right side of the figure above the buttocks, and the curve from this point to the broadest point of the hips and thence to the back of the knee is plainly indicated. It can be easily studied here how the line of the waist is affected by the position of the hip and the amount of fat thereon.

In this figure, the weight is thrown on the right foot, but the curve in the waist line here is flat because in this example there is little flesh on the hips and consequently the line is straighter. Were the hips fuller, the fleshy portion would cause them to appear higher and thereby emphasize this curve at the waist.

36. Study Showing Broad Simple Method of Modeling.—In Fig. 28 is shown another view of the male figure as seen from behind, and is an example of a very simple form of rendering. The hands clasped behind the back are simply indicated, and in this position give considerable prominence to the shoulder blades. There is no attempt at variety of tone here, except where the high lights fall on the shoulders and elbows. The hair is increased in tone somewhat, in order to contrast with the flesh, and a few strong lines are placed throughout the figure in order to express the direction of the planes. Although the hands are incomplete and roughly blocked, their position and pose can be readily felt; this shows the importance of expressing details well in mass. In the legs, there is no attempt at precision of outline, yet they are drawn in with a bold, free sweep that shows the artist had a definite idea of points of start and arrival; the position and direction of each line was determined before the crayon was placed to the paper. For instance, at the juncture of the right thigh with the abdomen, a point of start was established and the line sweeps boldly and freely to the knee, which is the definite point of finish, and from here to a point above the instep another line is drawn.

37. Study Completed in Full Modeling.—A good example of a fully modeled female figure, of still a different type, is shown in Fig. 29. The outlines are clear, the shadows are softly blended, and the whole drawing is rendered to give a finished effect of light and shade as it existed in the original.

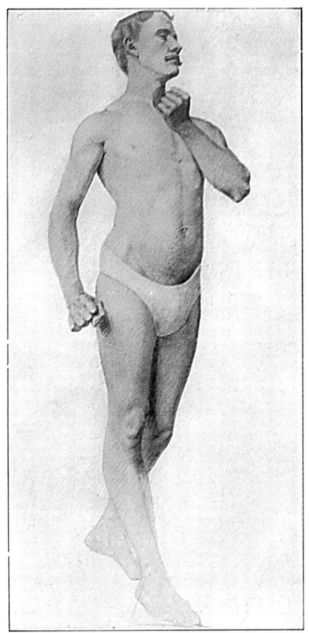

FIG. 30

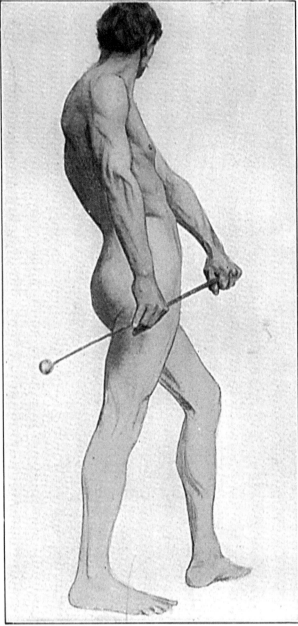

Drawn by Wм. B. Gilbert

Fig. 31

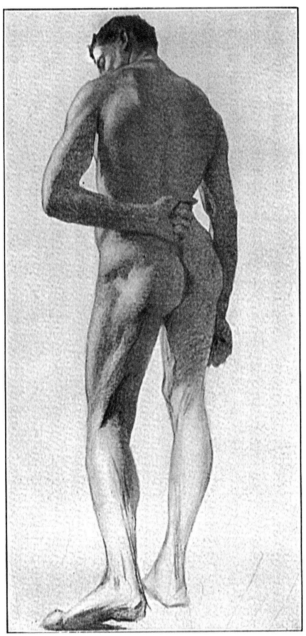

Drawn by MELVIN NICHOLS

FIG. 32

The body rests, as before, on the right leg, throwing the right hip somewhat above its normal position. The back of the right hand rests above the hip, causing a depression of the flesh at this point, and the line of the upper portion of the body should be nearly straight from the arm to the intersection of the wrist and the waist. This line is not straight, however; it is concave at the beginning and ending and convex in the middle, because of the prominence of the muscles of the back. The muscles of the forearm are rather full, but neither the upper arm nor the forearm is perfectly straight but both are slightly curved. The convexity of the upper arm and the concave contour of the inside of the arm consist of a number of delicate curves and not one even curve.

Note carefully the lines bounding the planes of shadow down the entire right side of the body, and that these planes blend into the high light on the front of the abdomen. The accented shadow under the right breast outlines this feature, while the left breast is crushed into the forearm, causing a depression in the left forearm from the wrist half way to the elbow. This must be carefully rendered in order to prevent a distorted appearance in the left arm.

The line from the intersection of the body with the left arm to the prominence of the thigh, appears at first to be composed of two concave curves with one convex curve between them. Careful study, however, will show that between the convexity of the abdomen and the prominence of the thigh, the line is rather convex and not flat. The knee on the left leg is sharply defined, and the fulness back of the knee is decidedly prominent. The right leg is in full front view, showing the points of prominence on the inside and outside of the calf, the fulness of the ankle bone, and the general trend to concavity from the bottom of the trunk to the ankle bone caused by the curvature of the bones in this member.

The modeling on this study is completed almost entirely by the use of the stomp. The shadows, being generally placed and their planes well defined, should be blended off softly into the high lights by gentle touches with the end of the stomp, the deeper shadows being added and worked in with the smaller

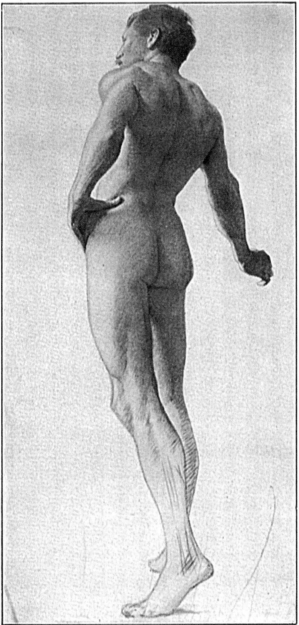

Drawn by CHAS. A. PULCIFER

FIG. 33

stomp where required. Where the contours of the muscles
are to be emphasized, as in the knuckle, under side of the right
arm, and about the knees, careful touches of the crayon-charged
stomp will express the planes and can afterward be flattened
off into the surrounding planes where required.

**38. Three-Quarter Front-View Study of Male
Figure.**—In Fig. 30 is shown a very carefully modeled study,
fully rendered (except the lower legs), of the male figure, and
one that will bear long and careful study. The figure is posed in
such a manner that it brings the principal muscles of the upper
portion of the body into prominence. This light graceful figure
is an admirable one for study, for the sweeping lines are not
cut by excessive muscular development nor rounded off by
fatty tissue. The median line from the pit of the throat to
the navel is clearly marked, and is of the greatest assistance
in drawing, inasmuch as one could easily build upon it the
relative proportions of the figure.

The entire outline is made up of short, straight lines, as
for instance in the right arm, from where it joins the shoulder
to the inside of the elbow; and in the forearm, where the inside
contour is composed of a series of short, broken, straight lines.
Observe, too, the general curvature of the right leg, throwing
the right foot well under the center of the body. The feet as
sketched here appear abnormally large, but this is due to the
fact that the figure is almost entirely above the eye and the
feet are much nearer the point of view than is any other portion.

39. Side-View Study of Male Figure.—In Fig. 31 is
shown the male figure in a good pose. The interest is centered
in the head and right arm, the muscles of the neck giving a clear
idea of the effect of turning the head, while the muscles of the
arm are thrown into prominence by the pose of the figure. The
left shoulder appears considerably below the right owing to the
fact that the figure is seen from below. The hands are well
brought out, as the knuckles catch the light and form points
that must be carefully located in order to preserve the proper
construction. While the front of the body is mainly composed
of a single sweep from the neck to the ankle, an analysis of it

will show that it consists of a series of convex lines subtly joined to one another so as to mark prominences due to muscular development. The deep shadow on the back contrasted with the high light on the upper arm, and the darkened hands profiled against the high light of the hip, tend to throw the right arm into prominence and give the figure a feeling of depth and solidity.

40. Rear-View Study of Male Figure.—In Fig. 32 is shown a rendering of still another type of male figure, in a pose that reveals new features in the modeling of the figure. Most of the figure is expressed in monotone with a few high lights placed to give modeling an occasional deeper shadow to emphasize the form. Attention is called to the transparency of the shadow over the back; there is no feeling of deadness there, but simply of partial shade. If the eyes are slightly closed, the planes of light and shade become very strongly marked. These planes of light and shade should be carefully studied and an effort made to outline them before the shadow tone is placed on the drawing. Care must be taken not to overwork the shadow to make it too dark; also where two shaded portions are in contact the high lights in the deeper shadows must be well placed in order to emphasize the outline. For instance, the left hand placed in the hollow of the back is rendered in practically the same tone as the back itself, but the small high light on the upper part of the hand and the deepening shadow under the wrist, give it outline and permits it to contrast with the tone against which it is placed. The upper side of the thumb, however, receives no high light, and as a matter of fact merges into the shadow of the back; but the eye feels the presence of the outline, as also of the ends of the knuckles, yet all that is placed there to convey that impression is the simple shading between the fingers. The whole solidity of this figure is based on a keen sense of light and shade and a clear understanding of where one begins and the other ends.

41. Three-Quarter Rear-View Study of Male Figure.—Fig. 33 shows another light graceful pose of the male figure. The point of interest in this figure lies in the study of

the foreshortening. The eye of the artist was about on a level with the ankle of the model, and as the figure leans slightly forwards, parts of it are materially foreshortened. The left elbow becomes very prominent, while the forearm tapers rapidly to the wrist owing to the fact that it is more distant. The right arm is similarly drawn, the taper of the muscles of the elbow to the wrist being even more conspicuous here. The vigorous treatment of the outlines where a series of simple lines block out the general form should be studied. The high light under the left arm tends to throw the left arm into the foreground apparently and increase the effect of foreshortening. The lines across the shoulders and hips are at such an angle that one readily feels the height of the figure above the eye.

DRAWING FROM LIVING MODELS

LIVING MODELS AND THEIR ARRANGEMENT

42. Function of Living Models.—While drawing from charcoal studies, photographs, and casts familiarizes a person with the proportions of the human figure and gives valuable training in the rendering of the human form, the art student must be able to draw from the living model before he can successfully portray human beings in his illustrations. But the fact that he is not able to draw from professional models should not be considered a disadvantage, for usually it is quite easy to induce friends to pose for short periods of time, and it is sometimes possible to sketch persons who are not aware that they are serving as models.

For general practice it is well to have the model elevated somewhat above the level of the eye. To accomplish this, the model should stand on a box or platform, while the effect of elevation may be still further increased by the student working in a sitting posture as low as possible. A convenient easel can be made by inverting an ordinary kitchen chair. The drawing board can thus be rested at a convenient angle with its lower edge upon the rounds of the chair, and at the same time the student can plainly see the model.

43. No one should undertake to make finished drawings from a living model without having first had considerable practice in drawing from the plaster casts. There is no harm, however, in making sketches from the figure that require no longer than 15 or 20 minutes' time, if full and proper attention is given to the direction of the lines and the position of the masses. But the student must be familiar with the forms of the different parts of the body as they appear in the plaster casts before he can successfully draw from the living model. No matter how steady it may be, the living model will unconsciously change its posture under growing fatigue, and unless familiar with form and construction the student will draw one part of the figure as it first appears and another part as it appears after the model has sagged from fatigue.

44. Suggestions for Practice Work.—While the exercises on the drawing plates at the end of this subject require figure drawings made direct from the living model, it is necessary for the student to do a certain amount of preliminary practice work in drawing from living models as he studies the following pages. This practice work is not to be submitted to the Schools. Detailed suggestions for various groups of figure postures, and the making of studies from them, will be given later.

STUDIES MADE DIRECT FROM LIVING MODELS

45. Groups of Subjects for Sketching.—In order that he may acquire skill in drawing from living models, the student is expected to make drawings of some of the subjects suggested in the five groups that follow. In no case are these figures to be drawn in action and all are to wear their ordinary dress. The poses called for are not tiresome; therefore, the student should have no difficulty in securing his models.

GROUP 1.—Some senior male member of the family, as grandfather, father, older brother, husband, uncle, etc., as the case may be, talking over the telephone, full figure showing; reading a book or newspaper; writing at a table or desk; standing, at window or in front of fireplace, smoking cigar or

pipe. Or, if practicable or desirable to make partially draped or undraped studies, in running trunks or gymnasium suit, ready to exercise; in bathing suit, ready for dip in lake or ocean; or in any other natural and easy posture in repose.

GROUP 2.—Some senior female member of the family, as grandmother, mother, older sister, wife, aunt, etc., as the case may be, engaged in occupations or occupying postures as follows; the costume or dress in each case being such as is ordinarily worn for such occupation or posture: Sewing or knitting at window or by lamplight; rolling dough at kitchen table; leaning on fence or gate talking to some one; seated in rocking chair with hands in lap. Or, if practicable or desirable to make partially draped or undraped studies, in gymnasium suit, ready for gymnasium exercise or basketball game; in bathing suit, ready for dip in the water; or any other position in repose.

GROUP 3.—Some junior male member of the family, as younger brother, son, etc., as the case may be, standing, cap on head, books on strap, ready for school; sitting on bank of stream, fishing; flying a kite; building a snowman; or other erect position. Or, if practicable or desirable to make partially draped or undraped studies, on bank of stream, disrobed, ready for a swim.

GROUP 4.—Some junior female member of the family, as younger sister, daughter, etc., as the case may be, in street dress, with hat, gloves, etc., ready for a walk; seated, reading or writing; standing at a window, looking out, profile showing. Or, if practicable or desirable to make partially draped or undraped studies, in bathing suit, ready for a dip in the water.

GROUP 5.—If he is not living at home to take advantage of groups 1, 2, 3, and 4, that is, if boarding or living among strangers, the young artist can secure some acquaintance— as for instance, a room mate or other associate—to pose; or if not to pose specially may make sketches from this acquaintance (or even from strangers) in any of the following positions: Man, or woman, reading book or newspaper; man resting at noon hour eating his lunch; woman resting at noon hour; police-

man standing on corner; newsboys, bootblacks, or other characters, in repose. If practicable or desirable to make sketches from the partially draped or undraped figure, a visit to the gymnasium or swimming pool of the local Y. M. C. A. or Y. W. C. A., and a tactful talk with the physical director, will doubtless result in permission to make at least a hasty time sketch from the partially draped figure of some one in gymnasium costume or swimming suit.

46. Studies From Undraped Figures.—While the figures used in the great majority of illustrations are draped, or costumed, it is necessary first of all to imagine and draw the figures under the drapery, or clothing. Practice must, therefore, be had in drawing the undraped figure. While many people consider the studying and drawing of the undraped figure a most delicate subject, such studying and drawing must not be considered from the standpoint of sentiment or morals. A knowledge of the proportions, contours, muscles, textures, etc. of the human figure is absolutely essential to the art student who desires to perfect his training in figure drawing. Advantage should therefore be taken of every opportunity to study and make drawings from the undraped figure in various postures, and of individual parts of the figure.

FIGURE DRAWING EXERCISES

GENERAL INFORMATION

47. Tests in Drawing the Figure in Repose.—As before, the required work here will consist of drawings arranged as plates. These eight plates will be of uniform size and prepared and forwarded according to a systematic plan. Each plate will be $12\frac{1}{2}'' \times 19''$, being one-half of the regular $19'' \times 25''$ sheet of charcoal paper. Each plate will have no subdivisions, but it will contain the drawing of the human figure as large as possible; and the dimensions of the cast drawings or the figure drawings will be clearly specified in each case, the arrangements being such that the drawings will have generous margins around them. The plates are to be sent to the Schools, two or

more at a time, for inspection as was done in some preceding subjects.

48. The work of these plates will carry out the well-rounded method of training in figure drawing, namely: making drawings direct from the plaster casts or text illustrations; making other drawings from charcoal studies; and making the remaining ones from living models in repose. Hence, Plates 1, 2, 3, and 4 will be made from the plaster casts; Plates 5 and 6 will be made from other artists' charcoal studies of figures and from photographs of figures reproduced as text illustrations; Plates 7 and 8 will be made direct from the living models in repose.

49. Preliminary Practice Work (Not To Be Sent In).—When drawing and rendering the plates required, practice work should first be done in drawing the various figure studies in charcoal outlines. Then, on each plate, the study should first be blocked in with charcoal outlines, and later worked up in charcoal tones properly placed and graded, charcoal outlines being eliminated by blending into backgrounds or into the figure itself.

50. Character of the Plates.—Most important of all the articles of equipment that the student wants for this work are the plaster casts from which the studies should be made. These studies should be made in charcoal on charcoal paper. In connection with the work in certain previous subjects, a sufficiently large quantity of charcoal sticks, charcoal paper, and other materials for working was doubtless secured not only to do the work at that time, but also to do the work that followed. However, should the supply of any materials become exhausted, a new supply should be purchased at once.

51. In general, the methods of working followed in the preparation of drawings made in previous subjects are to be used here. Reference should therefore be made to the previous directions for methods of placing the objects to be drawn, blocking in the proportions freehand, testing the drawing for accuracy, and particularly the directions for rendering the drawings in charcoal, the making of practice strokes, and practice in making

flat and graded values, and to the four graded steps of rendering a charcoal drawing that were learned in a previous subject.

Although these methods are to be supplemented by certain concrete practices and plans particularly adapted for portraying properly figures in repose, yet they must be borne in mind as fundamentals of procedure when doing any kind of drawing and rendering work. To these general directions for methods of working must be added the specific methods of portraying the figure in full modeling, the texture of flesh, of costumes, etc. that have been given here. When the drawings of the plates are made, these specific directions should be referred to and the drawings made in accordance therewith.

PLATE 1

52. Exercise for Plate 1.—This drawing is to occupy the full 12½″ × 19″ sheet for Plate 1. To make this drawing, make a blocking-in drawing, either from the cast or from text illustration of the cast of the block form of the head, arranged as a three-quarter view, so that the sides of the face and of the nose show. This position agrees with that illustrated in the text. Make the drawing about 10 inches high and 7½ inches wide at the widest part, and all parts in proper proportions. Follow the methods of lighting and of working described in the text. Use charcoal or soft pencil.

53. Final Work on Plate 1.—Letter or write at the top of the plate, Plate 1: The Figure in Repose, and, on the back of the sheet, the class letters and number, name and address, and date. Hold the plate until Plate 2 has been completed, after which send both plates 1 and 2, in a mailing tube, to the Schools for inspection. Proceed now with Plate 2.

PLATE 2

54. Exercise for Plate 2.—This drawing is to occupy the full 12½″ × 19″ sheet for Plate 2. To make this drawing, make a finished charcoal rendering, direct from the plaster cast of the head shown blocked in for Plate 1. Place the cast in the same position, and make the drawing the same size as for Plate 1. Follow the methods of rendering in charcoal pre-

viously described and used. Suggest a background and include a ½-inch margin of white paper all around the rendering. This rendering should show complete modeling as illustrated in Fig. 9. Spray the drawing with fixatif as usual.

55. Final Work on Plate 2.—Letter or write at the top of the plate, Plate 2: The Figure in Repose, and, on the back of the sheet, the class letters and number, name and address, and date. Forward the plate, along with Plate 1, in a mailing tube, to the Schools for inspection. Proceed now with Plate 3.

PLATE 3

56. Exercise for Plate 3.—This drawing is to occupy the full 12½″ × 19″ sheet for Plate 3. To do this exercise, make a blocking-in drawing, either from the cast or from the text illustration, of the statuette of the female figure arranged as a front view of the figure, showing the up-raised right arm. This position agrees with that illustrated in Fig. 18. Make the drawing 12 inches high and all parts in their proper proportions. Follow the methods of working that have been already described. Use charcoal or soft pencil as desired.

57. Final Work on Plate 3.—Letter or write at the top of the plate the title, Plate 3: The Figure in Repose, and on the back of the sheet the class letters and number, name and address, and date. Hold this plate until Plate 4 has been completed, after which send both plates, in a mailing tube, to the Schools for inspection. Proceed now with Plate 4, unless there is some work to be redrawn or rerendered on previous plates.

PLATE 4

58. Exercise for Plate 4.—This drawing is to occupy the full 12½″ × 19″ sheet for Plate 4. To do this exercise, make a finished charcoal rendering, direct from the plaster cast of the statuette of the female figure, which was blocked in for Plate 3. Arrange the cast in the same position and make the drawing of the same size as in Plate 3. Follow the method of modeling and expressing the values by means of charcoal which was previously described, and the technique illustrated in the frontis-

piece. Suggest in the rendering a neutral background and allow a ½-inch margin of white paper all around the rendering. Spray with fixatif as usual.

59. Final Work on Plate 4.—Letter or write at the top of the plate the title, Plate 4: The Figure in Repose, and on the back of the sheet the class letters and number, name and address, and date. Forward the plate, along with Plate 3, in a mailing tube to the Schools for inspection. Proceed now with Plate 5, unless there is some work to be redrawn on the previous plates.

PLATE 5

60. Blocking-In and Rendering for Plate 5.—Make a blocking-in drawing from the charcoal study of the female figure shown in Fig. 29, first carrying the drawing as far as those in Figs. 19, 20, 21, and 22, using proportioning lines and guide lines. Make the drawing 14 inches (seven heads) high and make all the parts of the figure in proportion. Use charcoal lines lightly placed. Then, using these blocking-in outlines as a basis, make a finished charcoal rendering of the female figure shown in Fig. 29, keeping the modeling and the portrayal of the flesh values as shown in the methods illustrated in Figs. 22, 23, and 24.

Do not allow any blocking-in or proportioning lines to remain in the finished rendering; it should look like Fig. 29. Spray with fixatif as usual.

61. Final Work on Plate 5.—Letter or write at the top of the plate the title, Plate 5: The Figure in Repose, and on the back of the sheet the class letters and number, name and address, and date. Forward the plate in the mailing tube provided. Proceed with Plate 6 at once.

PLATE 6

62. Blocking-In and Rendering for Plate 5.—Make a blocking-in drawing from the charcoal study of the male figure shown in Fig. 30, first carrying the drawing as far as those in Figs. 19, 20, 21, and 22, using proportioning lines and guide lines. Make the drawing about 16 inches (eight heads) high

and make all parts of the figure in proportion. Use charcoal lines lightly placed.

Then, upon these blocking-in lines as a basis, make a finished charcoal rendering of the male figure shown in Fig. 30, using the modeling and the expression of flesh values as shown in the methods illustrated in Figs. 22, 23, and 24. Do not allow any blocking-in or proportioning lines to remain in the finished rendering; it should look like Fig. 30. Spray with fixatif as usual.

63. Final Work on Plate 6.—Letter or write at the top of the plate, Plate 6: The Figure in Repose, and, on the back of the sheet, the class letters and number, name and address, and date. Then forward the plate, in a mailing tube, to the Schools for inspection. Proceed now with Plate 7 if all required redrawn and rerendered work has been completed.

PLATE 7

64. Exercise for Plate 7.—Make a fully rendered charcoal drawing direct from the living model—that is, from some member of the family or some friend who will pose for a few minutes—of a female figure in a typical attitude. Suggestions for various attitudes and actions of female figures costumed or partially draped or undraped are given in the text. If no living model is available, the drawings may be made from magazine illustrations. Follow the method of working described in the text, and make the drawing fit conveniently onto the sheet, say about 14 inches high. A preliminary drawing may be made on a separate, smaller piece of paper (as the page of an 8″ × 10″ sketchbook if desired), the smaller sketch then being enlarged to be 14 inches high. Spray with fixatif as usual. It is not expected that this drawing shall be made from a professional model; some friend or relative will serve very well for the purpose.

65. Final Work on Plate 7.—Letter or write at the top of the plate, Plate 7: The Figure in Repose, and on the back of the sheet the class letters and number, name and address, and date, and forward the plate, in a mailing tube, to the Schools

for inspection, or hold it to send with Plate 8 when completed. Proceed now with Plate 8, if all required redrawn work in this subject has been done.

PLATE 8

66. Exercise for Plate 8.—Make a fully rendered charcoal drawing direct from the living model; that is, from some member of the family or some friend who will pose for a few minutes, of a male figure in a typical attitude. Suggestions for various attitudes and actions of male figures, costumed and partially draped or undraped, are given in the text. If no living model is available, the drawing may be made from a magazine illustration. Follow the method of working described in the text, and make the drawing fit conveniently into the rectangle, say about 16 inches high. A preliminary drawing may be made on a page of a sketchbook, and then enlarged to the proper size, 16 inches high, for the plate. Spray with fixatif as usual. It is not expected that this drawing shall be made from a professional model; some friend or relative will serve very well for the purpose.

67. Final Work on Plate 8.—Letter or write at the top of the plate, Plate 8: The Figure in Repose, and on the back of the sheet the class letters and number, name and address, and date, and forward the plate (with Plate 7 if not previously sent) to the Schools for inspection.

68. Next Work To Be Taken Up.—Up to this point the student has learned to draw still-life objects and has also learned the proportions of the human figure, and how to make drawings of the figure in repose, from plaster casts, from other charcoal studies, and from the posed living model. He doubtless understands that the most advanced stage of drawing the human figure is that which requires drawings to be made from the figure in action. That, therefore, will be the next subject that the student is to study; and it should be taken up at once, if all the plates of his course so far have been satisfactorily completed and properly graded.

THE FIGURE IN ACTION

Figures in action shown in gymnastic exercises.

THE FIGURE IN ACTION

ACTION

1. Action Contrasted With Repose.—It has been learned that the chief characteristic of the standing figure in repose is the manner in which it is disposed about a vertical center line of support, this center line remaining stable and undisturbed. When the stability of this vertical line of support becomes disturbed the figure makes an effort to regain its equilibrium; this effort is termed **action.** The action may be involuntary; as stumbling, falling, etc.; or it may be voluntary; as walking, running, gesticulating with the arms, etc.; but in either case it is the result of disturbing the equilibrium of the figure, or, as expressed in mechanics, disturbing the center of gravity.

That point in a body in which the body, when acted on by gravity or other parallel forces, is balanced in all positions is the **center of mass,** or, as more commonly called, the **center of gravity.** The nearer this point is to the ground or other supporting object, the more stable is the body; that is, the more difficult is it to upset or tip the body.

2. In the case of the human figure, the center of gravity is in the upper part of the trunk, midway between the shoulders. As a result, the human figure is not as stable as many other figures and objects. That such is the case is well illustrated by the necessity for a person to brace himself with legs and feet when a heavy wind is blowing, or to lean against the wind when walking in the face of it. If a vertical line $x\,y$, Fig. 1 (a), is dropped from the center of gravity, when the figure is standing erect, it will be in the median line of the body, and, passing

down through the body and between the legs, will touch the ground near the heels, as shown in (a) and (b). Even though a weight, or pull, is applied to one side of the figure, as when the figure is carrying a pail of water, the other side simply leans away from the weight, or the other arm is stretched out away from the weight, and the center of gravity is not seriously disturbed, for it is kept at a point exactly above the point between the heels of the standing figure. As long as this condition exists; that is, when the center of gravity is not

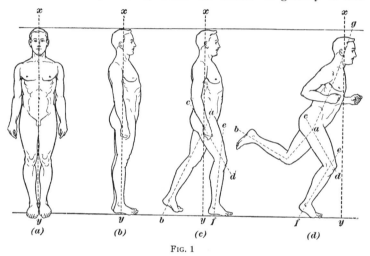

FIG. 1

seriously disturbed, the figure is said to be **in repose;** and it is the figure in repose that has been studied so far.

3. When this center of gravity is so seriously disturbed that it requires quick and violent action to restore the body's equilibrium, as when walking or running, or if it is entirely overthrown, as when falling, then action is shown in the truest sense of the word. Walking and running simply consist of starting to fall forwards on one's face, and then suddenly recovering one's balance by thrusting one leg and foot forwards. Note in Fig. 1 (c) that the upper part of the body is pushed slightly in front of the line of balance $x\,y$, and would fall if it were not for the right foot being thrust quickly forwards.

In (*d*), the attitude of running portrays this still more plainly; the center of gravity at the bottom of the throat is then thrust violently forwards, the trunk of the body becoming inclined as shown by line *g a*. If nothing else were done the figure would fall flat on its face, but it is saved from doing so by thrusting first one leg *a f*, and then the other *a b*, forwards and thus restoring balance. Observation will show that when a man stumbles or trips over some obstruction he takes little running steps to keep from falling.

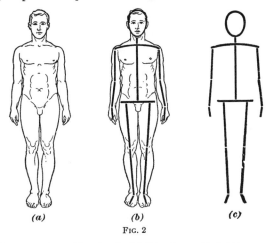

(*a*) (*b*) (*c*)

Fig. 2

4. Expressing Typical Attitudes of Action.—As has been suggested, when the human figure is being drawn it may be considered as a number of flexible hinged solids, which in turn may be reduced to the simple form of an egg-shaped outline for the head and flexible hinged pipes, or lines, for the trunk, shoulders, pelvic bones, arms, hands, legs, and feet. The position of these lines is shown in Fig. 2. View (*a*) shows a front view of the figure. In (*b*) the figure is shown with the heavy black lines placed over it to show the framework; an ellipse is drawn for the head, a slightly curved horizontal line for the shoulders, a straight horizontal line for the hips, and straight vertical lines—properly placed and hinged—for the neck, trunk, arms, hands and legs. In (*c*) is shown this heavy line framework by itself.

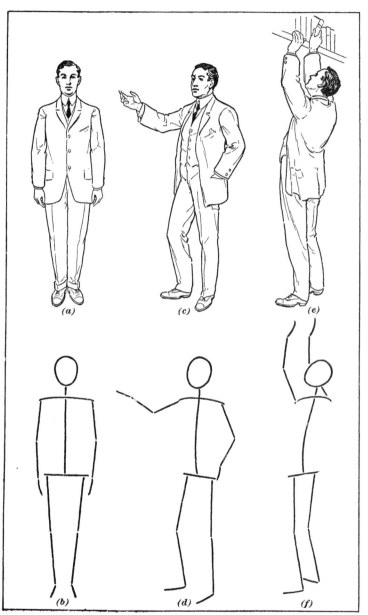

(b) (d) (f)

Fig. 3

5. With the human figure in this simplified form, it is easy to block in any form of action. A few typical forms of action and the method of expressing them by framework forms are shown in Fig. 3. In (a) is shown the front view of the figure in repose; its framework lines are shown in (b) directly beneath it. In (c) is shown the familiar pose of a man making a speech; his right arm is extended, his left hand is in his coat pocket, and his right knee is slightly bent. The framework of this figure is shown in (d) directly beneath. In (e), the figure is reaching the arms up over the head as if to place some books upon a high shelf; and in (f), directly underneath, the framework lines show these actions clearly, the bent spine, the back tilted head, the upstretched arms, etc.

6. In Fig. 4, examples of more violent action are shown. In (a) the figure is jumping. Not only does the position of legs portray this action, but the arms, drawn up tightly, assist largely in showing such action. In (b), directly below, the framework lines give a very clear idea of how the action of jumping can always be expressed. In (c), two men are boxing; the framework lines, in (d), directly underneath, show clearly the bent back and legs and upcast arms of the one and the vigorous forward lunge of the other, and thus give a graphic idea of the leading lines in a drawing of two figures boxing or fighting. In (e), the man starts to run rapidly; in (g), he is in full flight and covering the ground rapidly; and in (i), he stumbles and falls, or pitches forwards from exhaustion. These forms of violent action are expressed by the framework lines of (f), (h), and (j), respectively. In (f), the framework lines show the head thrust forwards and the back bent forwards; the left arm is stretched forwards and the right arm backwards; the legs are crouched to give impetus to the first spurt or dash in the run. In (h), the framework lines show the head kept vertical, although the back is nearly horizontal and curved backwards; the upper and lower legs in each case make right angles with each other; one foot is on the ground and the other is in the air nearly as high as the body; the arms are outstretched. In (j), the framework lines show the action

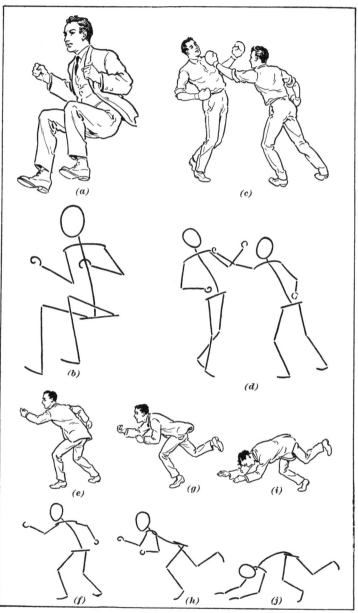

FIG. 4

of running violently arrested by a tumble; the arms are out-
stretched to save the runner; the back is again bent forwards,
and the upper and lower legs are still at angles with each
other because the impetus of running has not entirely ceased.
These examples of action by no means cover all, nor a great
proportion of, the forms of action observable in men and
women every day, but the principle of the framework lines
and their method of placing can be readily applied to any
form of action.

7. Limitations of Movement.—When drawing the
figure in action it is very necessary that no expression of
movement on the part of the entire figure or any portion of
it should exceed the bounds of possibility. Each part of the
body has a limit to its power of turning; therefore, when a part
is drawn beyond such limit, the drawing is not only thrown
out of construction but it oversteps the real purpose of legiti-
mate illustration. It is true that the caricaturist takes many
liberties, not only with the face, but with the actual con-
struction of the figure and its parts and their movement.
But the present consideration is with the normal and correct
drawing of the figure and its action; these must first be learned
before one can take the liberty to distort them and make
caricatures.

These limitations of movement can be learned only by
careful study and close observation. Sketches should there-
fore be freely made of all possible positions of the body and
its members and these sketches kept for reference. The
charts, books, etc., published by the makers of athletic goods,
showing exercises with chest weights, dumb bells, etc. should
also be procured and studied, for their diagrams and pictures
give, with great accuracy, the principal movements and their
limitations.

8. A few of the limitations of movement are as follows:
1. The forearm bends at the elbow only forwards from
the rigid upper arm. If the arm is rotated from the shoulder
the forearm may be directed to various positions, but its
movement is only a forward one, as if on a hinge.

2. The lower leg bends at the knee only backwards.

3. The hand and foot bend at the wrist and ankle, respectively, in a rotating manner over arcs not exceeding 180°; the motion is freer than that of the hinge movement of the elbow and knee.

4. The entire arm can rotate at the shoulder in every direction with the ball-and-socket movement, like the spoke of a wheel on the hub; it can also turn sidewise (back and front) being stopped only by the body.

5. The leg has the same general ball-and-socket rotation but with not so much freedom as the arm.

6. The head can bend forwards, backwards, to the right and to the left, and can also roll around, or rotate. In turning the head, however, the large neck muscles prevent its turning around very far, so care must be taken as to how much profile of the face is shown when the body is drawn in full-front view.

7. The trunk can be bent forwards quite far, like a jack-knife, but its backward movement is quite limited in normal persons. The side and rotating movements are also limited.

DRAWING FROM PHOTOGRAPHS

INTRODUCTION

9. Function of Snapshot Photographs.—It is extremely difficult to be able to sketch, from life, figures in rapid or violent action, expecially when one is untrained in such sketching. Usually, by the time he has decided upon the main action lines or framework forms, the subject has gone or the action and movement have been concluded. The best way, therefore, to start drawing figures in action is to take simple snapshot photographs of typical examples of action. These photographs may then be carefully studied and the positions of the different parts of the body and their relation to the ground and the line of balance learned; the drawing, too, can then be made at one's leisure. But these photographs

are to be used only as records of typical action forms and must not be slavishly copied. There are many forms of action, especially if violent or rapid, that are caught by the eye of the camera that are not caught by the human eye. For this reason, a snapshot of a rapidly running horse is quite likely to show the legs in a somewhat cramped or stiff position, because the rapidly acting lens and shutter of the camera have caught the rapidly moving legs in a small fraction of a second when they were passing from one position to the next. However, when the human eye sees motion it registers upon the retina a succession of images, not simply one isolated one, as does the lens of the camera. Therefore, when making drawings from snapshots of figures in rapid action, allowance must be made for this phenomenon, and the constraint or stiffness must be eliminated from those parts that appear stiff and awkward. In snapshots of mild action this stiffness, or appearance of arrested motion, is not particularly noticeable.

10. Suggestions for Practice Work.—It is understood that no drawings are to be sent to the Schools until this Section has been carefully studied and understood; but the student is expected to make, for his own practice, action sketches from snapshot photographs as he proceeds with the study of the text. These studies (made in charcoal) may be from the snapshots reproduced in this Section or in current magazines, from snapshots made by friends who have cameras, or from snapshots made by the student himself.

USE OF CAMERA

11. Necessity for Using Camera.—Every student is supposed to have a camera and to use it freely. This camera need not be an expensive one, however, for cameras that sell for $2 to $10 take suitable snapshots of most subjects. The rapidly acting lenses and shutters of the higher-priced cameras, though, greatly enlarge the scope of one's work and increase the number of rapid movements that can be photographed and, consequently, studied.

The actual operating of the snapshot camera and the taking of pictures requires no especial study or training. Explanatory booklets accompany the camera; and, furthermore, the local dealer who sells the camera to the customer is always ready to give any needed explanation as to its use, the method of loading it with the film, using the finder, etc. At first, it may be advisable to have the films developed and the prints made by a reliable photographer, but the processes of developing and printing are easily learned and the work may be readily done by any one who is willing to devote the necessary time to it.

12. Subjects to Photograph.—When beginning to study movements by means of snapshot photographs, a definite course of procedure should first of all be planned. Then the subjects should be carefully chosen and the exposure made when the movement wanted is within the field of the finder. At first, only the simpler forms of action should be photographed; for example, a man walking, a man running, a horse and wagon jogging leisurely along the street, laborers working, a man gesticulating as in making a speech, two persons boxing, two persons conversing, a man riding a bicycle or a horse, etc. As one becomes familiar with taking such photographs, more violent or rapid motion may be photographed; for example, a horse running rapidly, a man on a motorcycle, an automobile at high speed, a motor boat plowing through the water, etc. Then groups of people in action may be taken, in so far as the field of the picture will accommodate them.

SPECIMEN PHOTOGRAPHS OF ACTION

13. As specimens of the kind of snapshot photographs of the figure that should be made, there are reproduced in the frontispiece, facing page 1 of the text, and in Figs. 5 to 14, certain typical forms of action. These not only serve to suggest subjects that may be photographed as action studies, and how they may be arranged, but they also show some interesting things as to the positions into which

the human body places itself when in violent action. A careful study of each one will show the characteristic positions of the body in its various forms of action. These photographs were taken with a rapid-action lens and shutter, and the student cannot expect to duplicate, with an ordinary camera, some of the most violent actions shown.

14. Walking.—Fig. 5 shows a body of men walking. It should be noted that the opposite arm to the leg is the one that swings forwards; that is, when the left leg moves for-

FIG. 5

wards the right arm moves forwards and when the right leg moves forwards the left arm moves forwards, thus preserving balance. It should also be noted how straight are the legs in all the figures, and that the foot on the leg that moves forwards is turned up to such a marked degree that a great part of the sole of the shoe shows.

15. Catching and Batting.—Fig. 6 shows characteristic positions of the batter who has just hit the ball and the catcher

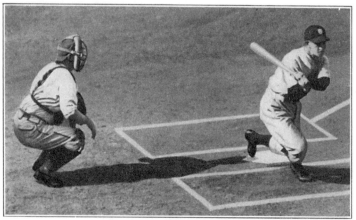

FIG. 6

who was ready to catch the ball in the event of the batter fail-
ing to hit it. Attention is called to the manner in which the
batter leans forward, and to the legs just starting the action of
running. The crouching position of the catcher and his manner
of holding arms and hands are typical, Baseball "fans" will
recognize the naturalness of the action of each player.

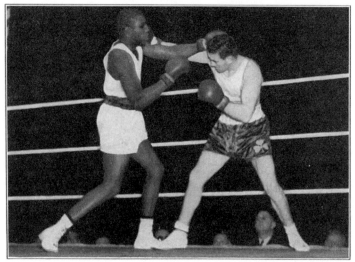

FIG. 7

16. Boxing.—Those who follow the sport of boxing, either through active participation, actual attendance, or through the descriptions of a radio announcer, will recognize the typical aggressive and defensive tactics of the two boxers shown in Fig. 7. In this "still" photograph the student has the opportunity of seeing not only the positions of the arms, as one fighter leads with his right and protects himself with his left, while the other leads with his left, but he can see the

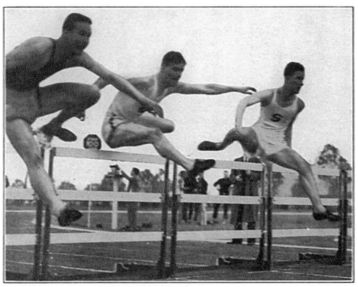

Fig. 8

lowered head attitude of the fighter on the right, and the manner in which both fighters have missed landing any blows. The widespread legs and feet of the man on the right indicate how he has braced himself to prevent being knocked over.

17. Hurdle Racing.—The ordinary jump shows the figure in a crouching position with little characteristic action of legs and arms beyond that which can be easily sketched. However, the action of the running and jumping figure in hurdle racing reveals strenuousness of action that bears study.

In Fig. 8 the men have not only been running rapidly, but they have used great effort to leap over the hurdles. This illustrates two forms of action combined. The method of thrusting one leg forward and over the bar while the rest of the runner's body is being "pulled" over the hurdle is graphically illustrated.

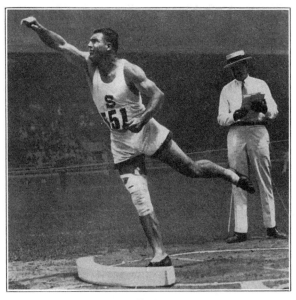

Fig. 9

18. Putting the Shot.—Fig. 9 shows the athlete putting the shot, and is particularly valuable for study. Here again is shown the action of checking the body's impetus to dash forwards, by means of the firmly planted and braced right leg and the balancing left leg and left arm.

19. Pole Vaulting.—In few forms of action is gracefulness more clearly shown than in pole vaulting, as illustrated in Fig. 10. In fact, the figure, just after it has "cleared" the high bar, seems to float through the air as would a bird. As a matter of fact, the figure in this position is practically at rest at the moment just before it starts to fall.

20. Weight Throwing.—When the athlete throws the small shot or weight, the action differs markedly from the throwing of a heavier weight. In Fig. 11 is shown the position of a man who is getting ready to put the shot. His left arm is extended for the purpose of balancing his body, for the

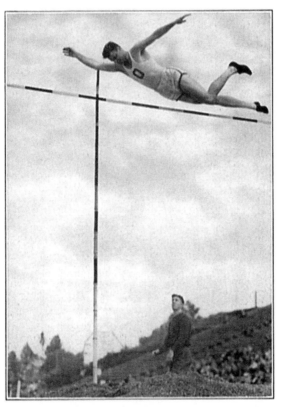

Fig. 10

forward motion of his whole body is added to the shoulder and arm thrust in order to give force to the throw. This figure is well worth study, not only for the attitude of this particular athlete, but also for the beautifully modelled arms, neck, and torso, and the working of the muscles. The lighting is such as to reveal the muscular structure very plainly.

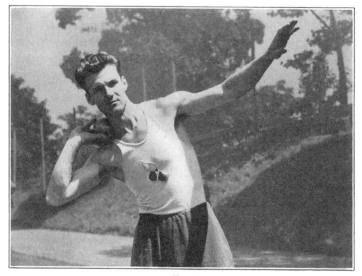

FIG. 11

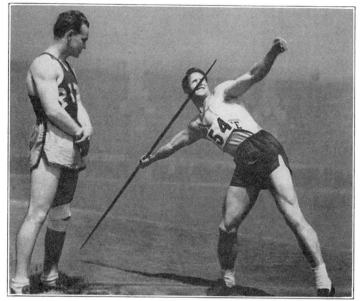

FIG. 12

21. Throwing the Javelin.—Among athletes this very ancient sport, throwing the javelin or spear, is one that always attracts interest. The poise of the body as it is drawn back, the working of the arm and leg muscles, and the very graceful

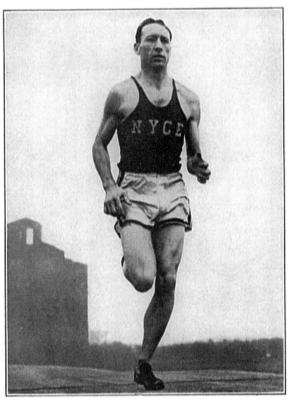

Fig. 13

action of the whole body are well shown in Fig. 12. Seldom does one have the opportunity of seeing such a fine "still" photograph of this typical action.

22. Running.—The two examples of a man running, as shown in Figs. 13 and 14, should prove of great value to the student of the figure in action. It is difficult for the average sketch artist to portray with sufficient quickness this very

common form of action, and yet a running man must frequently
be used in pictorial compositions and fiction illustrations. The
action of leisurely running, or the ending of a race, is well
shown in Fig. 13, where the athlete is moving forward but at
the same time is keeping his body erect. In Fig. 14 very rapid

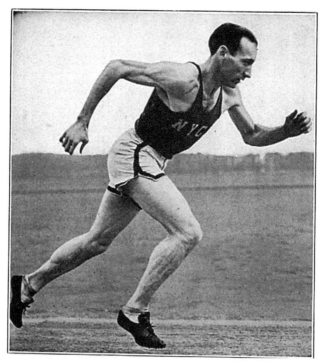

Fig. 14

running is illustrated, and not only should the student observe
the alternating positions of legs and arms (right arm with left
leg, and left arm with right leg) but the muscular structure on
arms and legs should be carefully observed.

23. Use of Moving-Picture Scenes and Magazines.
Moving pictures, and the magazines devoted to moving pictures,
are of great value to the art student. Not only do they give
him an opportunity to study facial expressions but they enable

him to study a wide variety of forms of action. They are of advantage because they are actual illustrations, and the types of action are purposely made dramatic and graphic, just as should be the action of the figures in a newspaper, magazine, or book illustration. These actions should therefore be studied with the greatest care and hasty memoranda sketches made in a convenient notebook. This can be done readily, for most moving-picture theaters are now partly lighted, while the moving pictures, very brilliantly lighted, are being thrown upon the screen.

The magazines issued by the producers of motion-picture films are profusely illustrated by very clear reproductions of photographs from the films shown on the screen. These are practically snapshot photographs, and record in permanent form a wide range of forms of action of all types of men, women, and children.

MAKING SKETCHES FROM PHOTOGRAPHS

24. While a collection of snapshot photographs of human figures in action will prove of value simply as memoranda, the purpose of preparing such snapshot photographs in this connection is that preparatory practice may be had in blocking in the leading lines of action of the figures, and then filling in the other details. The method of making such action sketches has already been discussed, but further instruction will be given in connection with the making of time sketches and rapid-action sketches direct from the figure.

After the films have been developed and prints have been made, the photographs should be carefully studied and the characteristics of each form of action sought. Then enlarged charcoal drawings, properly blocked in and rendered, should be made by the methods used when drawing from the charcoal studies of the human figure.

First of all, the framework of action lines that express the head, body, and limbs of every figure, or animal, in the picture should be carefully placed. Then the proportioning and blocking-in lines should be drawn and then the figures modeled

with a fair degree of completeness. These drawings will very forcibly acquaint the student with typical forms of action and how to express them.

25. The photographs and the drawings may be mounted in a scrapbook, properly arranged and indexed. The general title of the scrapbook might be Typical Forms of Action of Human Figures. One section or group of pages may be headed Walking; another, Running; another, Climbing Stairs; another, Carrying Loads; and so on. In this way a book will be formed, the pages of which will be of inestimable use in a practical way at a later period. As a matter of fact, scrapbooks and memoranda of this kind are prepared and used by the most practical and businesslike of the present-day successful illustrators.

The distinct advantage in practicing on the snapshot photographs is that, in them, the action is recorded in permanent form and cannot get away, and therefore action sketches in soft pencil or charcoal may be made therefrom at leisure.

DRAWING FROM LIVING MODELS

INTRODUCTION

26. Function of Living Models.—A realistic drawing of the human figure in action can be made only after training and experience have been had in drawing the figure in repose from special studies and photographs, from casts, and from the posed figure, and after making drawings of action studies from photographs. One who has done such preliminary work is ready to draw direct from the living model in action. Nothing will serve for this purpose except the living models themselves, in action. For time sketches, these models may be posed; but for action sketches, one must be constantly on the alert and in readiness to make sketches from men, women, and children that are seen every day, walking, running, jumping, etc.

27. Suggestions for Practice Work.—Detailed instructions are here given for making sketches of action from living models; these are illustrated with time sketches made in charcoal. It is expected that the student will prepare similar sketches as he studies, not only as a preparation for the rendering of the drawing plate work but as a necessary preparation for the portrayal of action in his illustration work later. These practice sketches are not to be submitted to the Schools at this time.

MAKING TIME SKETCHES

SKETCHES FROM THE UNDRAPED FIGURE

28. To make a faithful portrayal, direct from living models, of figures in action requires careful training and experience. The first step in this training is the making of quick *time sketches* from models in arrested action; that is, quick sketches from a model posed in such a position as to express action but remaining stationary. For instance, a man might be posed as if throwing a ball, having arm up above head, holding ball, the other arm balancing, and a leg raised to give impetus to the throwing of the ball. Even if the lifted leg is steadied by resting it on a stand or chair, the model will find it quite difficult to hold that position for more than a few minutes. For that reason, only a sketch that will quickly but accurately portray the action of the model, without any detailed rendering or modeling, can be made.

29. Method of Making Time Sketches.—The method of making time sketches is the same as when sketching from a model in repose, except that in time sketching some of the stages are not actually placed upon the paper. As the work must be done quickly and as the proportions and blocking-in lines of the figure are now known, it is only possible to suggest, roughly and lightly, the direction of the framework action lines, and then to clothe them by putting in, quickly but carefully, the main curves of the figure.

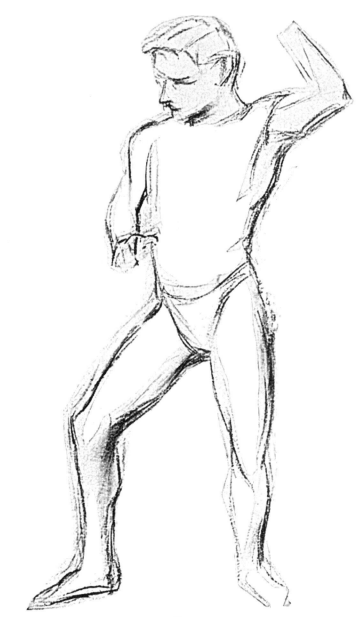

Fig. 15

30. The procedure can best be illustrated by examples of such time sketches, as shown in Figs. 15 to 25, made direct from models by the artist Violet Roberts, and used here with her permission. In Fig. 15 is shown a time sketch of an action pose, the model being represented as fencing. First the usual points were quickly established; these are the top of the head, soles of the feet, and the bottom of the trunk, then the bottom of the chin, the shoulders, armpits, and knees were located.

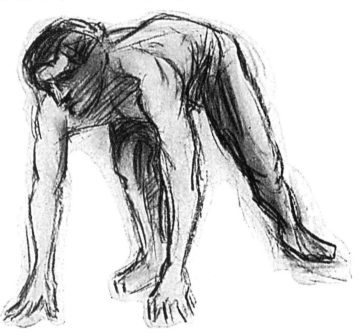

Then the action lines were lightly put in, and finally (and that which shows most plainly in the drawing) the main curves of the figure were drawn quickly but carefully. In doing such work one must feel one's way and should not use heavy lines, for these may be incorrect; only light accurate lines should be drawn. The different parts of the figure must be constantly compared with one another, and with the figure as a whole, as the drawing proceeds. It is of primary importance that the

equilibrium of the figure be properly maintained and expressed, the center of gravity and line of balance being placed as previously explained.

31. Figs. 16 and 17 are also excellent examples of the simple manner in which a time sketch of a figure in arrested

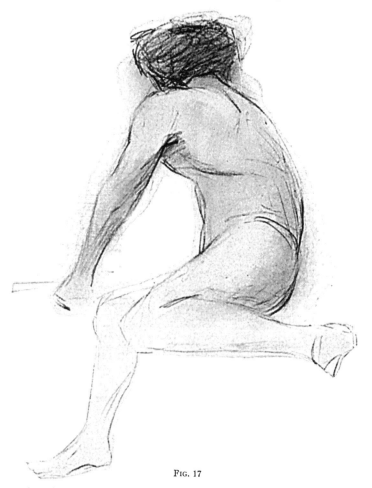

Fig. 17

action is started, and they will bear very close study, for they will reveal to the student the proper way to start such

FIG. 18

FIG. 19

Fig. 20

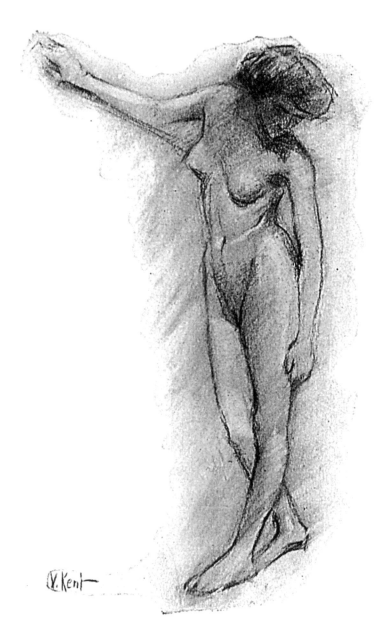

FIG. 21

a sketch. The next step in the treatment (all worked very rapidly of course) is to put in with good bold lines clearly-fixed contours at places where a muscle or bony structure comes, thus giving solidity to the figure. This is well shown in Figs. 18 and 19.

When making time sketches from the female model the angular lines used for the male model should be abandoned and softer, more delicate, and gently curving lines should be used. The female figure is less muscular (at least the muscles are better clothed with fat) than the male figure. Figs. 20 and 21 are good examples of time sketches from female models and have been worked up in the stages previously described.

32. Technique for Time Sketches.—The reproductions of time sketches from nude figures just illustrated, show not only lines but also an even blurring, with high lights taken out. This effect is obtained by using for the rough blocking-in lines the point of the charcoal stick, getting the swing of the figure by using long lines. Then the lines are rubbed lightly with a piece of chamois skin, thus softening the lines and placing a slight tone over the space occupied by the drawing. The necessary lightening of the spaces on the limbs to express roundness is done with a clean part of the chamois skin and the brighter high lights are lifted off with a kneaded rubber. The most prominent shadows, and the crisp accents and the lines to give modeling to the figure are then placed. The tint, or tone, produced by rubbing the drawing, serves as a slight background and also as a half tone on the figure, thus relieving the high lights.

Studies of this kind are not made on regular charcoal paper, or even on water-color paper, for these are too rough; they are made on "Steinbach" paper or board, or what is known as *illustrators' board*, the surface of which is even and regular with a slight tooth, like bond paper, but not smooth and polished.

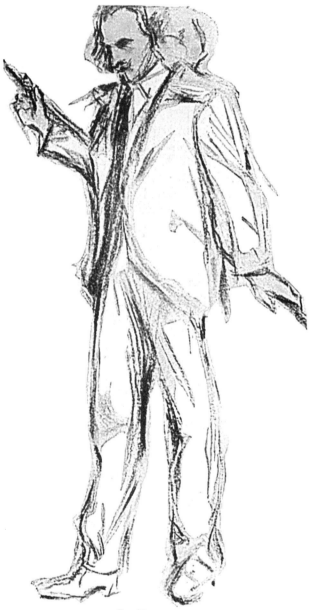

FIG. 22

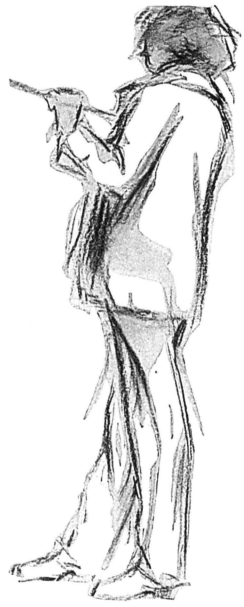

FIG. 23

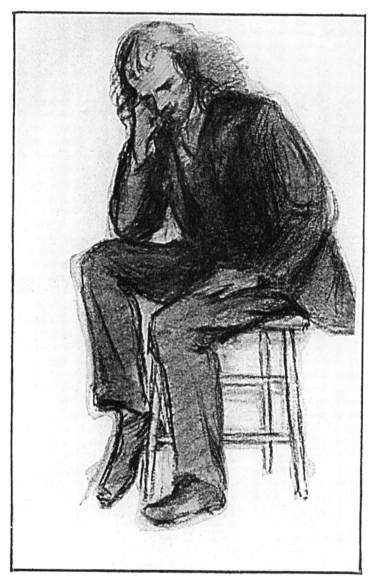

Fig. 24

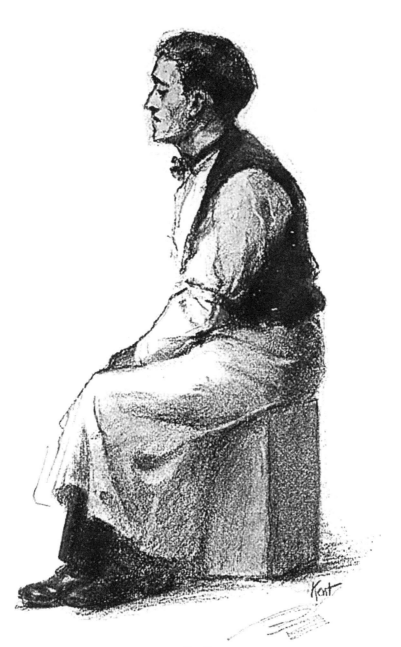

FIG. 25

SKETCHES FROM COSTUMED FIGURE

33. The next step in practicing drawing from the living model in action is to make time sketches from costumed models in arrested action. It would be very unwise to attempt to draw costumed figures; that is, figures wearing everyday clothing, without first knowing how to draw nude figures. When drawing any costumed figure, one should always know just the shape and modeling of the body and limbs under the clothing.

Figs. 22 and 23 show the rough but accurate blocking in of the leading lines of the costumed figure. It is perfectly evident that the one who made these time sketches had a full appreciation of the solidly modeled body underneath. The method and technique of preparing such time sketches is the same as that employed in making time sketches of the undraped figure. These two reproductions should be carefully studied and note made as to what lines are considered the main ones, and which can therefore be properly drawn in the short time allowed.

34. Figs. 24 and 25 show time sketches of costumed figures carried still farther by means of tone values suggested on the clothing. In Fig. 24, the values are only lightly indicated but in Fig. 25 the modeling is carried quite far, so that not only are the finished values expressed but, to a degree, the actual textures of the material are shown.

MAKING RAPID-ACTION SKETCHES

35. Quick Sketching from Unposed Subjects.—It is one thing to make studies and sketches from posed figures, but quite another to make sketches from figures in rapid and violent action when these figures make no effort to pose for or in any way accommodate the one who is sketching. Before a person can make a sketch of a figure in violent action that is even fairly acceptable, he must spend a great deal of time observing how figures move and act. For instance,

if he expects to make sketches of men walking or running he must first watch them actually walking or running, as at a baseball game, or on the street. As he watches them he must carry is his mind what he has learned about the proportions of the human figure and the relations of the head and limbs to the trunk, and how these members move, and their limitations of movement. He must be able to see, just as if painted in bold black or white lines upon the clothing of the figures, the framework action lines previously described. By closely observing men walking or running he will form mental pictures of these actions so that he will think of them and see them in composite form. In this way his idea of a man walking will be an image that shows a combination of the various motions through which the man goes as he walks. By thus having observed, he knows exactly what he is going to draw before he touches his pencil to his paper.

36. Making Action Sketches.—Let it be supposed, then, that such careful and thorough observing of various forms of action has been done. To do the sketching, the art student should always carry with him a small sketching pad or book of bound sheets of drawing paper, say, 3 in. × 5 in. or 4 in. × 6 in. (which will easily fit into the pocket) and several well-sharpened soft pencils, HB, B, 2B, etc. Let it be assumed that the sketching is being done at a ball game, and it is desired to make a quick sketch of the pitcher, or perhaps of the catcher who is trying to throw a runner out at second base. It is evident that the player will not hold such an unstable position for 10 or 15 minutes for the accommodation of the student who is trying to sketch him. The artist's pencil must move rapidly under such circumstances, but as he knows just what it is he wants to sketch his procedure is simple and direct. He will first put in, with great rapidity, the action lines, as shown in Fig. 26 (a), by the heavy black lines. He already knows the relative proportions of these lines from his previous study of this subject, and all he needs to do, therefore, is to observe the direction and angles of these lines. After these action lines are placed, the general curves

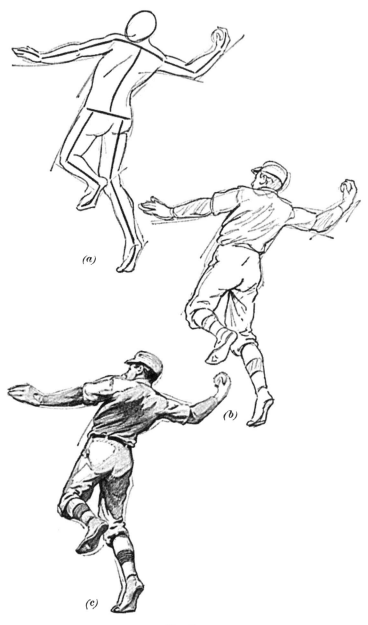

(a)

(b)

(c)

Fig. 26

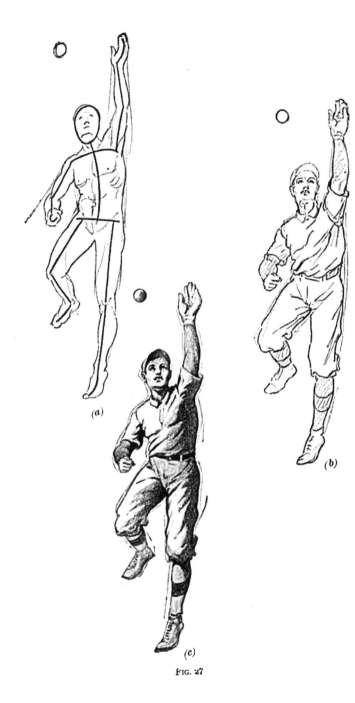

(a)

(b)

(c)

FIG. 27

of the body may be sketched in lightly, as also shown in (a). The pitcher will certainly again assume a similar attitude and the general contours of his baseball uniform may then be sketched in as in (b). If the attitude is not again assumed, it may be sketched in from the general knowledge and observation of baseball uniforms. In like manner, the rendering of the light-and-shade values may be worked up into a completed sketch, as in (c). There will, of course, be only one sketch when the student makes his drawing on the sketching pad; the three separate drawings shown are simply to illustrate three distinct stages of the same sketch.

37. In like manner, sketches of any other forms of action may be made with great accuracy. Fig. 27 shows the stages of making an action sketch of one of the fielders at the ball game running sidewise to catch a fly ball. In (a), the framework action lines are shown in black and the main contours of the figure lightly sketched in over these action lines. In (b), the general contours of the baseball uniform are put in; and in (c), the completely rendered pencil sketch is shown.

38. Sketches of Violent Action.—When the action of the subject to be sketched is still more violent, so that the subject will pass from the field of view in a few minutes or even seconds, the procedure of sketching is the same, only the powers of observation must be still more alert and keen and the pencil must move still more rapidly. Suppose that a sketch is to be made of a crowd of men chasing another man, as in Fig. 28 where the action certainly is violent. The main framework action lines of the runners can be blocked in in a few seconds, and the action lines and contours of these figures of the forms as shown in Fig. 28. The position of the men can be lightly suggested, to be afterwards detailed at leisure. Perhaps there will even be time, before the rapidly moving crowd has passed, hastily to plot in the general forms of the men, using the skeleton-line method, illustrated in Figs. 3, 4, 26, and 27. However, even if the group has passed out of view, these can be put in from general knowledge of the proportions of the running men and the thief. The artist, if he is quick of eye,

may even have time to recognize (and then later to remember) the types and colors of the clothing worn by the men.

It is understood that any artist who is making sketches of violent action may use a snap-shot camera, or a rapid-lens candid camera, to record such extreme forms of action. How-

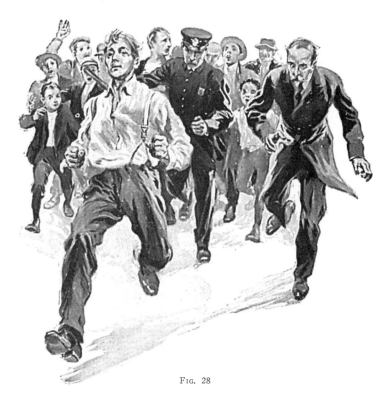

Fig. 28

ever, circumstances will arise where the artist does not have a camera with him, and the ability to sketch rapid action will be a great asset.

When a crowd is being sketched, such as in Fig. 28, a very good basis on which to start, and an important feature to fix correctly, is the eye-level line or horizon, which must pass through the eyes of all the persons in the picture.

39. These directions for making rapid action sketches are simple and will be found usable. They are the methods employed by professional artists and may be relied on. However, the young artist must remember that frequently he will make his sketches in crowds, where people will be looking over his shoulder and perhaps commenting (not always favorably) on what he is doing. He must not therefore become confused but must concentrate his attention and efforts on the securing of a correct sketch of the figure or figures in action.

In like manner, he must not allow the dramatic element of the situation to distract his attention. It is quite natural that men running will excite the onlooker; but if the student is trying to get an action sketch of the men running and chasing a thief, he must make his drawing as quickly and as accurately as possible and let some one else stop the runaway.

The self-control needed to work impersonally and with concentration on the sketch being made is difficult at first, but can be mastered with practice.

MAKING SKETCHES FROM MEMORY

40. Function of Memory Drawing.—It is not enough for a person desiring to become a newspaper or general illustrator to be able to draw from studies, photographs, casts, or living models the human figure in repose and in action. He must become so familiar with the proportions and modeling of the human figure and its typical forms of action that he can draw from memory the figure in repose or in action. There will be many times when the illustrator will have no one to pose for him, and he must depend on his memory. Therefore, he should be so familiar with drawing the figure that he can use it, singly or in groups, with just as much ease and freedom as he uses the letters of the alphabet. If the instruction that has been given has been carefully studied, and practice work done as advised, there should be no difficulty in drawing from memory the human figure in any desired position.

41. Suggestions for Practice Work.—In the following pages full instructions are given for cultivating the ability to draw from memory, and suggestions as to tests for such ability. One can never secure this ability unless he actually prepares drawings from memory and does the practice work in connection therewith. The student, therefore, will be expected to do such practice work, but the practice drawings are not to be sent to the Schools for criticism.

The best plan, when cultivating one's ability to make action sketches from memory, is first to make mental studies; that is, to observe carefully the figure in its various postures and actions, and then to attempt to draw these poses or actions (one at a time, of course) without looking at or referring to the original. This drawing should then be carefully compared with the original, and all points of difference should be noted, and should be carefully remembered. Another memory sketch of the same pose or action should then be made, and again compared with the original, and also with the first attempt, to see how close to actual conditions this second study has come, and whether errors and points of difference in the first study are corrected in the second one. This process should be repeated, and corrections made again and again, until one is able to make a correct memory study of the figure in repose or in action, without alterations or corrections being necessary. In addition to training the memory, this process develops the perceptive faculty because it forces one to observe everything more closely. The tests, or series of studies and corrections, should be made and remade from figures in all conceivable positions and actions.

42. A few of the postures and actions from which these memory drawings may be made are as follows:

A man ascending a flight of stairs.
A man leaning upon a gate or fence.
A man sitting in a chair, legs crossed.
A man walking or running.
A man on horseback.
A man pulling on a rope.
A man using a pick or a shovel.

A woman sweeping with a broom.
A woman carrying a bucket of water.
A woman throwing corn to chickens.
A woman combing her hair.
A woman leaning down in front of a stove.
A woman hanging clothes on a line.
A woman pulling weeds from a garden.

This list could be extended almost indefinitely, but the student will find that the making and correcting of memory sketches of these positions and actions will give him a very thorough training in drawing the figure from memory.

DRAWING EXPRESSIONS AND DRAPERY

INTRODUCTION

43. Importance of a Knowledge of Expressions. Although the positions and proportions of the features of the face have been studied, they have been considered only as parts of the entire human figure and as related thereto. As long as these facial features remain immobile they can serve no purpose whatever in an illustration. However, as soon as the human figure gets into action, the facial features also get into action, and there results **facial expression.** Closely connected with facial expression is **portraiture,** which is the depicting of those facial expressions of a person that distinguish him as an individual. Connected also with the consideration of the figure in action is the matter of **gesture;** and also that of **drapery,** because, in the practical application of figure drawing to illustrative or decorative work the figure is most frequently portrayed as being in action and as being draped; that is, clothed.

44. Suggestions for Practice Work.—Typical forms of facial expressions and gesture and how to draw them, and the principles of drapery and how to draw it, are here given. For the purpose of better understanding the descriptions given,

and as a preparation for the drawing plate work, the student will be expected to practice drawing facial expressions and gesture, and drapery, from the text illustrations and from life. A pocket sketch book and pencil, carried about with one at all times, will be useful for making such practice sketches. These practice sketches are not to be sent to the Schools.

FACIAL EXPRESSIONS

45. First of all, typical facial expressions must be recognized by careful and intelligent observation, after which they can be portrayed properly, if successful illustrations are to be made. Every illustration of any importance will require, on the face of one or all of its characters, expressions appropriate to that which is being illustrated. For instance, if the picture of two men engaged in a fierce hand-to-hand encounter shows their facial expressions in mild repose, as if they were sitting for their portraits, the whole effect of the picture as an illustration would be spoiled. The proper facial expression must be suited to the action of the figures or to the context of the quoted passage. Further, proper facial expressions must underlie any successful caricature or cartoon work. For the present, however, it is only the normal facial expressions that will be discussed. Later, training will be given in distorting and exaggerating these expressions so as to make caricatures.

A knowledge of all the typical facial expressions of emotions comes only after careful and extended observation of these expressions on the faces of persons that one sees every day in the home, on the street, in the office, and in other public places. Here, above all places, is needed on the part of the student the faculty of observation. Once observed, most of these typical expressions can be carried in the mind, but snapshot photographs or simple pencil sketches to serve as memoranda will be helpful.

Certain expressions that are characteristic of well-known emotions may be readily classified and their characteristics

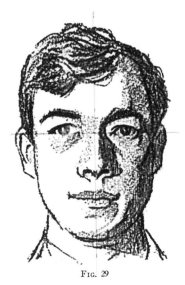

FIG. 29

FIG. 30

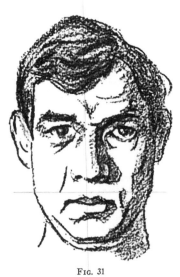

FIG. 31

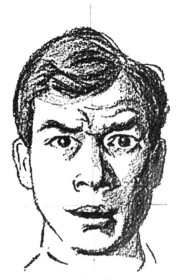

FIG. 32

easily remembered. In Figs. 29, 30, 31, and 32 are shown various expressions on the face of the same person. If, when studying the descriptions of these expressions, it is observed just how the effects of various expressions were secured in the illustrations, no difficulty will be met when depicting similar expressions in the drawing of faces and figures.

46. Repose.—When the facial features are in repose they are drawn just as has been described; they occupy their normal positions and the muscles are at rest. If the person is in good health there is no particularly marked expression on the face, although the eyes will probably have a glitter or snap to them, showing good health and plenty of life. Fig. 29 is a crayon drawing, direct from life, of the face of a young man with the features in repose.

47. Laughter or Smiling.—In laughter, or when smiling, the lips and the angles of the mouth are separated to a very marked degree and the teeth are shown. The corners of the eyelids wrinkle and turn up slightly, the eyes gleam, the sides of the nose are wrinkled, the corners of the mouth are raised and extended, and the upper parts of the cheek are raised so as to partly close the eyes. This last motion gives a pull on the muscles at each side of the mouth, thus making at those places very pronounced vertical curves, like parentheses, thus (). Fig. 30, showing the expression of smiling or mild laughter, is another crayon drawing of the face that, in Fig. 29, was shown in repose. If it were desired to portray violent laughter the mouth would be widely opened.

48. Joy, Cheerfulness, Contentment.—As far as outward visible expression is concerned, joy, cheerfulness, and contentment might be termed mild varieties of laughter and smiling. When expressing these emotions, the eyes have a brilliant gleam; the mouth is slightly open and its corners somewhat turned up, so that the teeth show slightly.

49. Sorrow, Dejection, Melancholy, Pity.—When depicting sorrow, dejection, melancholy, and pity, the following expressions, with variations, are noticeable: The muscles

of the face are greatly relaxed, and almost flabby. Sometimes the head is bent forwards. The eyebrows are extended upwards toward the center of the forehead. The pupils of the eyes are slightly raised and the eyelids droop. The corners of the mouth are sometimes lowered. The normal length of the face between the eyes and the mouth is considerably increased. In Fig. 31 is shown the expression of sorrow on the face shown in repose in Fig. 29 and expressing laughter and smiling in Fig. 30. On this particular type of face, which is strong and kept under good control, the feeling of sorrow does not so easily affect the muscles of the lower part of the face but it does affect the eyes and forehead. On a face whose features are more mobile, the appearance of sorrow would be more pronounced.

50. Grief, Pain, Anguish, Despair.—Grief, pain, anguish, and despair are all strongly allied with the preceding group. In grief, vertical wrinkles are produced between the brows. The cheeks and angles of the mouth are drawn downwards. The lips are slightly parted and the eyelids and the lower jaw droop.

In pain, there is some frowning. The mouth is tightly closed, the lips or teeth being pressed tightly together; in some cases the mouth is slightly opened.

In anquish and despair, the muscles of the face all droop and relax, and the eyelids droop.

51. Astonishment, Fear, Terror, Horror.—The typical expressions of astonishment, fear, terror, and horror are similar but they vary in intensity. The most noticeable parts affected are the muscles about the eyes and about the mouth. In fear the eyes, which are opened wide and show whites, stare directly at the person or the object that has caused the emotion. The mouth is partly opened; the forehead wrinkled horizontally; the eyebrows are raised; and, frequently, the hair has a tendency to raise itself from the scalp, although it does not actually stand on end as is sometimes described in fiction.

In terror and horror, in addition to the foregoing, the pupils of the eyes are greatly dilated. In Fig. 32 are shown the

expressions of astonishment and fear on the same face on which the other expressions have been shown in Figs. 29 to 31.

52. Anger, Fury, Rage, Hatred, Revenge.—A typical outward expression characteristic of anger, fury, rage, hatred, and revenge, when expressed, is that the head is raised and the muscles of the face are rigid; the lips are compressed; the eyebrows contracted; the eyes are glaring; and the veins of the head are noticeably swollen.

53. Scorn, Disdain, Contempt, Sneering.—The common expression of scorn, disdain, contempt, and sneering, is a slight elevation of the sides of the nose; a raising of one side of the mouth and thus slightly exposing the sharp side tooth. This is a somewhat "sneaky" expression, for it can easily be turned into a smile. Sometimes the chin is lifted and the face is partly turned away from the person or the object that excites the emotion; the lips are raised at the corners and the nose is wrinkled; the eye is half-closed, and the pupil lowered and directed toward the cause of the emotion.

PORTRAITURE

54. Portraiture, or the drawing of portraits of individuals, is dependent on the ability to see and draw the distinguishing features of a person. It therefore requires the ability to depict correctly the various facial expressions. The power to see the distinguishing features of a person is acquired by the concentration of the mental as well as the visual powers. But before he can do this a person must have a thorough knowledge of the shape of the head and the face, the shapes of the eyes, nose, mouth, lips, chin, ears, etc., and their proportions in relation to the whole face and to each other, and their proper placing on the face. The habit of thus observing features should become as much second nature as are the ability to recognize the letters of the alphabet and the ability to write. The standard forms and proportions that have been given should be made the basis of any portrait that is to be drawn.

55. Portraiture requires the observing of all points in which the features of the individual being sketched differ from the standard forms. In some faces, all the features of the face are crowded toward the center of the face, the eyes being close together, the nose small, the mouth close to the nose, and all the features surrounded by a large area of face. There are other faces in which the features are widely separated, the eyes being far apart, the nose long, the mouth far from the eyes, and the lips long. Some faces show thick hair coming rather low on the forehead, while others show thin sparse hair above a high forehead. Some faces show mustache, beard, whiskers, etc., and other faces are smooth shaven.

56. These distinguishing features must be carefully portrayed in the drawing. But first of all the main features of the face must be blocked in, as has been described, and the main lights, shade values, and shadows broadly expressed. Then the distinguishing characteristics that mark the individual must be drawn in as observed. It is not the purpose here, however, to train the student to make portrait studies. The methods of preparing portrait studies will be presented and practice given in making portraits when the various mediums and techniques for rendering are studied.

GESTURE

57. The facial expressions are always accompanied by movements of all parts of the body; these movements are termed *gesture*. By this term is not meant those studied movements made by orators and elocutionists to emphasize certain passages in their speeches and declamations, but rather the natural, spontaneous movements of the body, or some parts of it, that accompany the expression of emotion. For instance, laughter is often expressed not only by the facial movements but by a gesticulation with the arm and hand, slapping the knee, throwing backwards the head, etc. Fear or terror are shown by both the facial expressions described and a shrinking backwards of the body, and holding out the hands before one as a sort of protection.

58. There are certain emotions or feelings that are expressed more by gesture than by facial expression; some of these are as follows:

Doubt and **indecision** are characterized by shrugging the shoulders and a slight toss of the head.

Candor and **honesty** are shown by the head being held erect and by a direct fearless look.

Shyness is expressed by turning not only the face but the entire trunk to one side, or from side to side, as if to avoid facing directly what should be faced.

Self-consciousness and **bashfulness** are expressed by having the eyes looking downwards, a continual movement of the limbs and sometimes blushing.

Self-appreciation is shown by holding head and body erect, and a firm, decisive, confident walk.

Deceitful humility is expressed by a lowering of the head, a shifting of the eyes, rubbing of the hands and a shuffling walk.

59. **Sources for Observing Expressions and Gestures.** It has already been pointed out that these expressions should be observed in the faces and figures of people that are to be seen every day; this is, of course, the best method. Sometimes these opportunities are not of the best on account of the hasty and flitting view one gets of his subjects; therefore, one must be able to study them more at leisure. For this purpose, there is no better way than to observe the expressions of the actors in the legitimate drama or (for this purpose) in the just as valuable productions to be seen in the motion-picture theaters, familiarly known as moving-picture shows. Indeed, the pictures thrown on the screens are so large, clear, and distinct as to offer to one better opportunity to observe the various expressions at close range than in any other way; and the beginner is advised to make use of this excellent opportunity for this purpose.

There are also published monthly, by producers of the moving-picture films, magazines that give the stories of the newest films, illustrated by photographs from the actual

motion plays. These are also valuable to the art student, for here the emotions depicted are stable and permanent and can be studied at leisure. The ambitious beginner will see the advantage of keeping in touch with these motion-picture magazines.

DRAPERY

60. In order that successful studies of living models may be drawn, not only must the proportions of the figure and its parts, in repose, be understood, but one must be able also to draw drapery and costumes, because the models will be draped as a general rule. By drapery and costumes is meant simply the clothing worn day after day by men, women, and children.

It might be thought that there is nothing particularly difficult about the drawing of clothing; that all one needs to do is to draw what one sees. But the untrained eye does not usually see the draping of clothing correctly and therefore the young artist is not successful in depicting it.

61. Influence of Kind of Material.—In the study of drapery, the appearance of the folds and creases is dependent largely on the weight, thickness, and general texture of the fabric, and the way in which it is made up into a garment, as well as on its age and the uses to which it has been put. In an old coat sleeve, for instance, the folds or creases about the elbow will produce, as a rule, a repetition of themselves when the arm is again placed in the same position after having been changed. This is due to the repeated foldings in the same place. But in fresh cloths, the folds will arrange themselves differently, even though the cloth is placed approximately in the same position in which it was before. The study of drapery is therefore important, in order to observe the general directions of the folds under certain conditions and the representation of the texture of the material by the characteristics of the folds as well as by its light and shade. Heavy fabrics will hang in larger folds than lighter ones and will be blunter at the angles. Generally, however, the fold has a definite structure common to all fabrics under similar conditions.

62. In the case of an ordinary coat sleeve, which is practically a cylinder of cloth with an arm inside, the general trend and direction of the folds at the elbow will be practically the same in most cases even though the fabric is new; whereas, in a broad and loose sleeve, usually termed the Bishop sleeve, a more extensive range is likely to be observed and no set characteristics can be determined. In the same way, any tight-fitting garment will fall naturally into repetition of old creases. A tight-fitting pair of trousers will crease in much the same way each time the knee is bent; whereas, Zouave or bloomer trousers will display a great variety in the folds. It is a study of this variety of creases that gives character to the goods and the garment. Old clothes will naturally possess numerous creases; new clothes but few.

The gloss and smoothness of silk and satin cause them to catch the light and add another complication to the appearance of these folds. The reflection of light from one brilliant surface to one that is practically in shadow renders the shadow more transparent, and detail in the shadows much more clearly defined than with goods that do not reflect the light. Again, in semitransparent fabrics, such as cheese cloth and veilings, the effect of drapery is very complex, as the light is seen shining through one thickness, giving it a transparent effect, but beyond this it appears opaque owing to the fact that one or two thicknesses lie so close together as to form a solid material through which the light cannot pass.

63. In opaque fabrics with dull surfaces, such as woolens, the laws of light and shade are not influenced by the gloss or reflections from shiny surfaces; the appearance of these goods is then brought out by the modeling, in the same manner that one models the shadows on the human figure. All the convex portions of the folds receive high light, and the shadows cast from them on the concave portions are very dark. These numerous complications make it necessary to work always from the draped figure or model when rendering draperies, as the true characteristics cannot be expressed from mental conceptions until one has had great experience in this direction.

64. Supporting Surfaces for Folds of Drapery.
In this study of drapery, the point of chief interest is the
drapery that clothes the human figure; especially where and
how it is supported and how it falls away from the supporting
points and hangs in folds. The main supporting points or
surfaces are those from which the drapery usually hangs,
as the shoulders, or, in the case of a head-piece or shawl,
the crown of the head; the subordinate supporting points
are such places as obtrude or push out against the drapery,

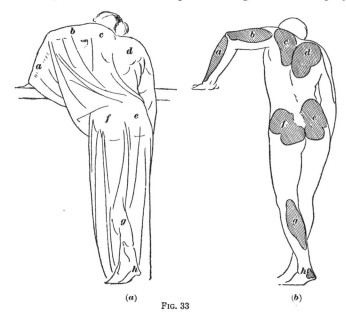

(a) Fig. 33 (b)

as the hips, the breasts, etc. A very convenient and practical
method is to outline the supporting surfaces to be afterwards
left plain, and then draw the folds as falling away from these
surfaces. This is shown in Fig. 33, where (a) is the rear
view of a draped figure leaning forwards, as if looking over
a wall, and with the left hand and arm raised as if resting on
the wall. In this case the drapery is supported at the left
forearm a, left upper arm b, left shoulder c, right shoulder d,
right hip e, left hip f, back of left leg g, and left heel h. At

these places the drapery is smoothed out as shown, and from them the folds fall away and hang in lines. In (*b*) is shown the general appearance of the figure under the drapery, and at the supporting points *a*, *b*, *c*, *d*, *e*, *f*, *g*, and *h*, the surfaces are contoured and shaded in, to show just where the drapery rests. The positions of these supporting surfaces will, of course, shift somewhat as the pose of the figure changes; but this principle of supporting surfaces should always be used where drapery of any kind is to be portrayed on a figure.

65. Folds Hanging From Supporting Surfaces.—The folds fall away from the supporting surfaces in gracefully curved lines that radiate like the flutings in a sea shell. The higher edges radiate and spread farther and farther apart

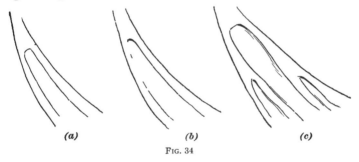

(*a*) (*b*) (*c*)

Fɪɢ. 34

until they become lost in the body or surface of the drapery. Between the raised edges of these flutes the drapery sags in a concave manner; this concave surface is usually shaded when making a drawing of drapery. In Fig. 34 (*a*) and (*b*), the beginning of the two raised edges of the flute is shown and, between them, the sunken or concave part. When the fold is long, the tendency is for each raised edge to again divide, making two more valleys or concave sags, as shown in (*c*). This system of subdivision may continue still further, and in fact the folds, or creases, do extend across transversely, but the general direction of the main ridges or folds falling from the point of support will be maintained.

66. It must be remembered that these groups, or systems, of folds frequently come together after having started from

several supporting surfaces. Where they meet, a sag or series of sags results. This sag, in its simplest form, is shown in Fig. 35 (*a*). It should be noted that the surface distance from x to y appears to be considerably less than from a to b and c to d; yet this distance is the width of the goods, which

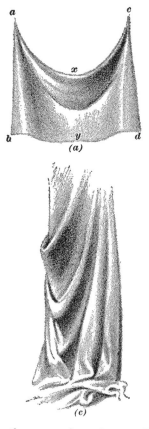

(*a*)

(*c*)

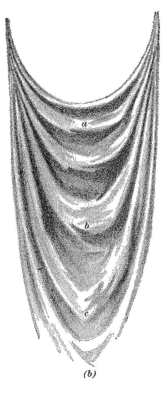

(*b*)

Fig. 35

is the same throughout. The part at x in Fig. 35 (*a*) simply sags downwards and forwards and pushes the part beneath it downwards and backwards.

In hanging drapery there is, of course, more than one sag, as is shown in (*b*), where a second, third, etc., follow below the first one. The first, or higher, ones have a tendency to

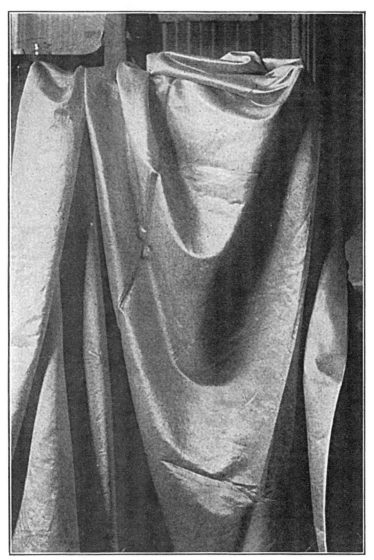

Fig. 36

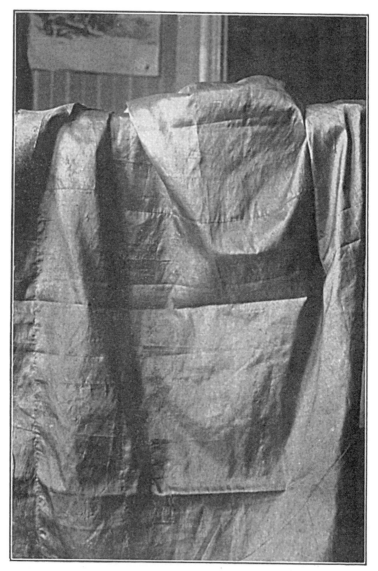

FIG. 37

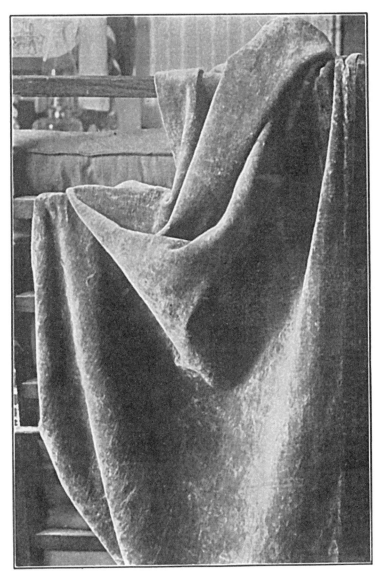

Fig. 38

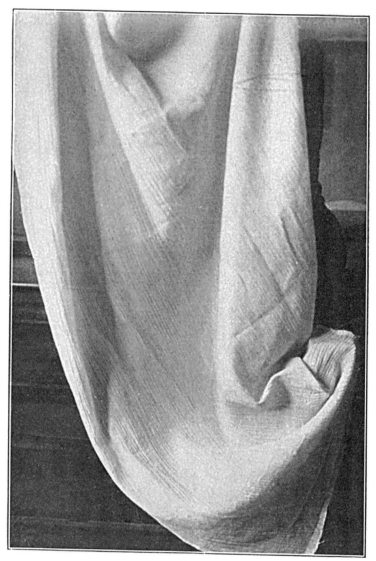

FIG. 39

be evenly curved, approaching the semicircle; the lower ones
become more pointed, as is shown by the folds *b* and *c*. These
duplex, triple, quadruple, etc., sags do not always hang so
regularly as in (*b*), but, depending on the weight and quality
of the goods, break up into sharp angular folds, sometimes
transverse, especially when they reach the floor, as shown in (*c*).

67. Texture of Drapery.—When depicting drapery, the
characteristic texture of the cloth must be shown in addition
to the appearance of the folds. Both of these points are
brought out in Figs. 36 to 42; the first four of these are repro-
ductions from photographs of different fabrics. In Fig. 36
is shown a piece of satin, which approaches nearest to a polished
surface in quality; it sharply reflects the light and the various
regions of light and dark are clearly marked. This character-
istic makes this texture much less difficult to render than
some others, the boldness of its planes being much easier to
perceive and to record than the subtle gradations of tone
in the cotton goods. The silk, Fig. 37, has somewhat the
same qualities as the satin, but is softer and more pliable
and is broken up into smaller planes, which are apt to be
angular and sharply defined. Velure, Fig. 38 (also velvet
and plush), has a peculiar shininess, which comes not where
one would naturally expect to find it—in the direct light—but
on the planes that are partly turned away from the light
and on the edges of the folds, where the light strikes the sides
of the masses of silken threads forming the long pile. The
planes turned directly toward the light are apt to be very
much darker; the blotchy effect is due to the nap being dis-
turbed in places, the surface being brushed in different direc-
tions. The light and dark regions are sharply defined, but
the edges are more softly blended than in the silk or satin.
Cotton goods, shown in Fig. 39, hang in rather limp folds;
the masses are large and simple and the contrast not great.
Starched cotton goods exhibit more sharply defined and
angular planes.

68. Fig. 40 represents a piece of old, blue velure, in which
the pile has been disturbed by considerable handling. In

addition to studying this figure, if possible, a piece of goods of similar texture (not necessarily of the same color), should be draped on a chair somewhat in the same manner; a small piece will answer even if it is in the form of a garment. In fact, this should be done with all the different textures, and all the points brought out carefully studied.

Fig. 41 shows a piece of delicate pink satin draped in large folds that hang somewhat like a lady's skirt. The ripple of light and shade, like reflections in moving water, should be carefully noted. It should be observed that all edges are not softened, many being clearly defined, while others disappear altogether. The folds lying on the floor, in the horizontal plane, appear darker than the upright folds.

69. The example shown in Fig. 42 is a piece of cotton drapery (cheese cloth), of a light, violet hue, arranged on a model; the figure is arranged in a sitting posture in order to give greater variety of planes. The three large divisions should be noted first: (1) From the neck to the hips, a vertical plane; (2) from the hips to the knees, a horizontal plane; (3) from the knees to the feet, a vertical plane. As the large mass of light falls on the horizontal plane, it should be observed how the interest centers in this spot and how the eye unconsciously comes back and dwells on that centered high light. The upper part of the figure fades gradually into the background, both in color and in tone; this, with the soft, greenish, reflected light on the right side and the shadowy suggestions of arms at the sides, gives a peculiarly realistic effect, so that one cannot help but feel that it is an object of three dimensions. It should also be noticed how the dark increases as it approaches the lights toward the bottom, lightens and becomes redder in the reflected light on the inner plane of the fold, and gradually melts into the deeper shadow again, changing into greenish gray. These soft gradations are characteristic of the shadowy parts of soft cotton drapery.

70. Application of Laws of Drapery to Modern Clothing.—While the principles underlying the folds and textures of drapery, as they have been learned, so far, apply to classic

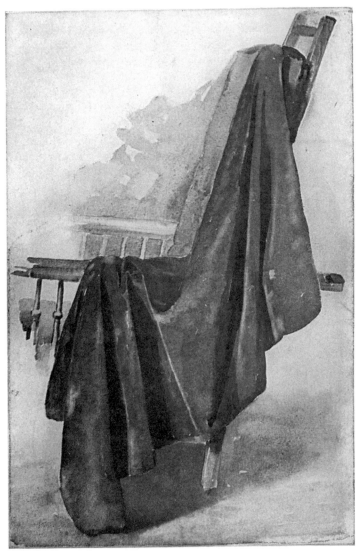

Fɪɢ. 40

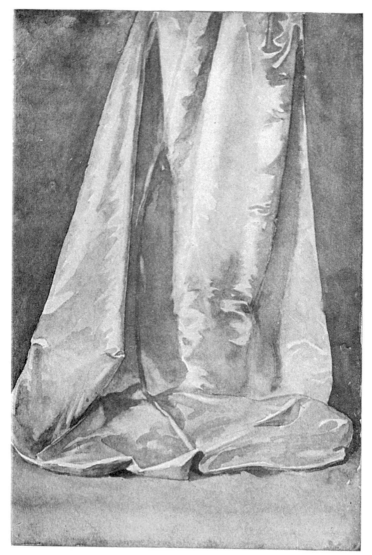

FIG. 41

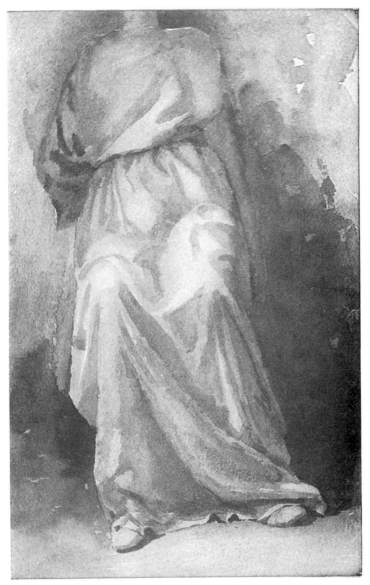

Fig. 42

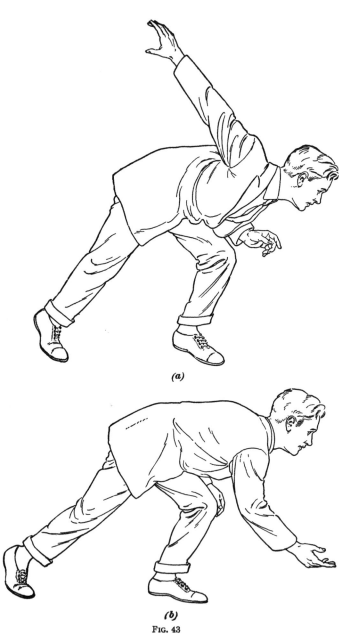

(a)

(b)

FIG. 43

draperies and to the modern dress of women, the cloth ordi-
narily used for men's clothing is so stiff and heavy and the
cut of the garments of such a character, that many new points
must be observed. One has only to look at the magazine
or street-car advertisements of men's suits, overcoats, etc., or
at the actual garments themselves as displayed on forms in the
clothier's windows, to see that every fold or wrinkle has been
carefully pressed out of them until they resemble nothing so
much as painted sheet metal. But when the clothes are worn
by the average man they quickly acquire folds and wrinkles
typical of these garments. The most common and noticeable
are those at the elbows of the coat, and at the knees and
thighs of the trousers.

71. In Fig. 43 (a) and (b) are shown typical examples of
the wrinkling of coat sleeves and trousers legs. These two
views represent two positions of a man when bowling. In (a),
he thrusts his right arm quite far back, as when getting ready
to throw the ball; this causes numerous wrinkles in the upper
part of the coat sleeve where it is attached to the coat, and
across the front of the coat from the place where is it buttoned
in front. These wrinkles are due to the backward pull that
is exerted on the entire right side of the coat when the arm is
drawn back. As the coat is buttoned about the body, it must
be the fairly loose part; that is, the upper sleeve, that will
give, and therefore the wrinkles appear as they do, diverging
lines from the point that receives the greatest strain, namely,
the under and front side of the sleeve hole.

In (b) the wearer of the coat extends his arm as when actually
delivering or throwing the ball when bowling, and, as will be
observed, quite a different set of wrinkles appear. The pull or
strain is due to the same causes as in the preceding case, but here
the wrinkles start from the back and under side of the arm hole
and run across the upper part of the sleeve and the side and
back of the coat itself. There are also characteristic wrinkles
at the inner side of the elbow where the cloth folds upon itself.

72. The same principles of wrinkling appear in the case
of the trousers, as also shown in Fig. 43 (a) and (b). When

the left leg is bent to nearly a right angle, as in (a), and the
weight is put upon it in the position of bowling, numerous
wrinkles appear in the trousers that do not appear when the
leg is vertical. The pull is tightly over the kneecap, and
the wrinkles are numerous under the knee and above the shoe
top. The wrinkles in the left leg in the bowling position
shown in (b) are practically the same as in (a); but in the
right trouser leg in (b) there are more long wrinkles than in
the right leg in (a), because in (b) the figure leans forwards
farther and thus stretches the cloth of the trousers. As in

(a)

Fig. 44 (b)

the case of the coat sleeves, the wrinkles always diverge or
radiate from the place having the greatest pull or strain.

73. In Fig. 44 (a) is shown the typical folding of the
cloth of the ordinary trouser leg over the instep of a high
shoe. In (b) are shown the wrinkles that occur in a rather
loose coat when the arm is raised; the wrinkles appear not
only across the upper part of the sleeve, but down the front of
the coat to the coat buttons. Here the drawings of the trousers
and coat are more fully rendered than those in Fig. 43.

74. Necessity for Observation and Making of Notes.
Only a few examples can be given of how the laws of drapery
are applied to men's clothing. The art student must keep

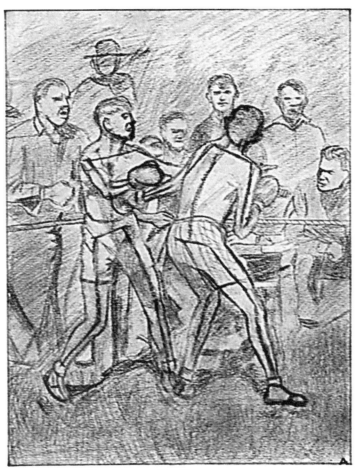

FIG. 45

his eyes open as he goes about, on the street, in public places, street cars, etc., and must make note of just what are typical folds or wrinkles, for certain postures, in the clothes of the people he sees. These should be sketched in a notebook, on scrap pieces of paper, backs of envelopes, or anything else that may be convenient. These sketches should then be filed away under classified headings and will be of great value later.

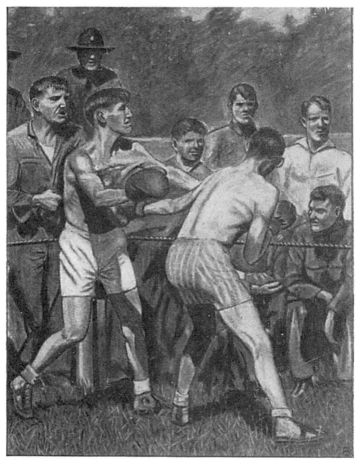

Fig. 46

75. Blocking-in and Finished Typical Action Drawing.—There are introduced in Figs. 45 and 46 companion drawings in charcoal of a group of action figures which show, perhaps more plainly than descriptive words, how the artist first blocked in the contour-line drawings for the entire group, and then those of the individual figures in the group, then drew and rendered the figures themselves, then rendered

the figures in action, and then finished the detailed rendering to complete the pictorial effects.

In Fig. 45 the student first of all arranged the two chief figures (the boxers) near the vertical center-line to give them prominence, and then grouped the interested spectators in the background. His next work was to block in the skeleton lines of action for both boxers and then put in the contour lines. Next, the main contours of the spectators were blocked in, no skeleton lines being needed for these figures in repose. This preliminary drawing was then completed by suggesting some of the relative tone values to be worked up later.

With such a foundation drawing as that shown in Fig. 45, a very carefully detailed rendering like that shown in Fig. 46 can be made, even after the most violent action has occurred. It will be observed that in Fig. 46 the student not only repeated his excellent action drawing and the grouping of the figures in the background, but that he carefully handled his tones of light, shade, and shadow so as to bring out the figures of the two boxers in bright tones, with interesting highlights, against the subdued tones of the figures and the landscape in the background.

These two illustrations are to be studied for method, but must *not* be copied for any regular assigned work that is submitted. All such assigned work must be original.

FIGURE DRAWING EXERCISES

GENERAL INFORMATION

76. Required Work.—The required work in this subject will consist of the preparation of four plates of drawing exercises of uniform size, about $12\frac{1}{2}$ in. \times 19 in., as in previous cases, being prepared and submitted to the Schools for comments as before. Some of the plates will be arranged horizontally and will consist of two $9\frac{1}{2}'' \times 12\frac{1}{2}''$ exercises each, one exercise showing the blocked-in action lines and the other exercise the finished pictorial rendering of the figure or figures in action. The remaining plates will be arranged and contain exercises as listed in the text descriptions.

Although only four plates are required to be sent in to the Schools, it will be good practice for the student to draw (but not to send in) the other diagrams and illustrations of figures in action. In fact, throughout his studies the student should do as much supplementary practice work as possible. The preliminary practice work is *not* to be sent.

77. Character of the Plates.—Charcoal is to be used in preparing the drawings; line work is to be used for the blocking-in drawings to show action lines, and blended tones to portray the completed drawings. Methods of work, in rendering the plate exercises, should be employed as directed in the text. A careful study of (but NOT a copy of) Figs. 45 and 46 should be made, to note another student's method of blocking in, and charcoal technique.

PLATE 1

78. Exercise A, Plate 1.—Exercise A is to occupy the left $9\frac{1}{2}''\times 12\frac{1}{2}''$ rectangle of Plate 1. To draw this exercise, make a time sketch, showing only the blocking-in lines and posture lines, direct from the living model, that is, from some one who will pose for several minutes, of a figure in arrested action. Prepare the drawing according to the method described in the text. Indicate at the bottom of the drawing the amount of time spent upon the sketch. Spray with fixatif and allow to dry.

79. Exercise B, Plate 1.—Exercise B is to occupy the right $9\frac{1}{2}''\times 12\frac{1}{2}''$ rectangle of Plate 1. To draw this exercise, make a finished detail rendering, same size and position, of the blocked-in time sketch from life prepared for Exercise A, finishing it as described for previous plates. Spray with fixatif and allow to dry.

80. Final Work on Plate 1.—Letter or write at the top of the plate the title, Plate 1: The Figure in Action, and on the back of the sheet the class letters and number, name and address, and date. The sheet may then be rolled and mailed to the Schools in a tube. If separate sketch-book pages have

been pasted on the sheet it may be folded once and mailed flat to the Schools as before described. Under no circumstances should a sheet of pasted-up sketches be rolled. This will result in creasing and folding of the small sheets, thus spoiling the drawings. The work of Plate 2 may then be taken up.

<div align="center">

PLATE 2

</div>

81. Exercise A, Plate 2.—Exercise A is to occupy the left $9\frac{1}{2}'' \times 12\frac{1}{2}''$ rectangle of Plate 2. To draw this exercise, make a blocking-in sketch, direct from a human figure in violent or rapid action, according to the method illustrated in Figs. 26, 27, and 28. Show with heavy block lines the action lines and block in the general contours of the rest of the figure. Make the figure about 8 inches or 10 inches high, and, if desired, make it on separate page of sketch book and paste in proper rectangle. Spray with fixatif and allow to dry.

82. Exercise B, Plate 2.—Exercise B is to occupy the right $9\frac{1}{2}'' \times 12\frac{1}{2}''$ rectangle of Plate 2. To draw this exercise, with the blocked-in sketch of Exercise A as data, make a finished detail rendering of this same action study, same size and arrangement as in Exercise A. Render the drawing completely as has been done in the case of previous plates. Spray with fixatif and allow to dry.

It is important that these drawings of violent action should be made direct from life, and not in any other way. The student must not try to evade the requirements of this plate, for his later success in this work will depend on such practice in drawing direct from living models in action.

83. Final Work on Plate 2.—Letter or write at the top of the plate the title, Plate 2: The Figure in Action, and on the back of the sheet the class letters and number, name and address, and date. The sheet may then be rolled and mailed to the Schools in a tube, or if separate sketch-book pages have been pasted onto the sheet it may be folded once and mailed flat to the Schools as before described. The work of Plate 3 may then be taken up, unless there is work to be redrawn on previous plates.

PLATE 3

84. Drawing Exercises, Plate 3.—This plate is to be vertical, and divided into four $6\frac{1}{4}'' \times 9\frac{1}{2}''$ rectangles. It is to contain charcoal copies of the four charcoal studies of expressions shown in Figs. 29, 30, 31, and 32. Each head is to be made about three or four times the size shown in the illustration and the exercises are to be arranged on the sheet as follows:

Exercise A is to be drawn in the upper left-hand rectangle; this exercise is the face with features in repose.

Exercise B is to be drawn in the upper right-hand rectangle; this exercise is the face smiling.

Exercise C is to be drawn in the lower left-hand corner; this exercise is the face expressing sorrow.

Exercise D is to be drawn in the lower right-hand corner; this exercise is the face expressing fear.

Spray all studies with fixatif and allow to dry.

85. Final Work on Plate 3.—Letter or write at the top of the plate the title, Plate 3: The Figure in Action, and on the back of the sheet the class letters and number, name and address, and date. Do not send this sheet to the Schools at this time, but hold it until Plate 4 has been finished. Proceed now with Plate 4, if all uncompleted work on previous plates has been finished.

PLATE 4

86. Drawing Exercises, Plate 4.—This plate is to be vertical, and divided into four $6\frac{1}{4}'' \times 9\frac{1}{2}''$ rectangles. It is to contain charcoal drawings of the four expressions of repose, smiling, sorrow, and fear; but, instead of being copied from other drawings, they are to be made direct from the face of some one who will pose. An excellent plan is to make the drawings from one's own face as seen in a mirror set up vertically before one as he works. The portrayals of these four expressions must be made from life. An unmounted photo-

graph of the person whose face is being portrayed should be sent along with the drawing plate. Send photograph separately if it is mounted. The four studies are to be arranged on the sheet as follows:

Exercise A is to be drawn in the upper left-hand rectangle; this exercise is to be the face with features in repose.

Exercise B is to be drawn in the upper right-hand rectangle; this exercise is to be the face smiling.

Exercise C is to be drawn in the lower left-hand rectangle; this exercise is to be the face expressing sorrow.

Exercise D is to be drawn in the lower right-hand rectangle; this exercise is to be the face expressing fear.

Spray all studies with fixatif and allow to dry.

87. Final Work on Plate 4.—Letter or write at the top of the plate the title, Plate 4: The Figure in Action, and on the back of the sheet the class letters and number, name and address, and the date. Place Plates 3 and 4 in the mailing tube and send them together to the Schools in the usual way for examination. If the photograph sent with Plate 4 is mounted on a card, send it separately, or send the plates flat, after folding them once to size $9\frac{1}{2}$ in. $\times 12\frac{1}{2}$ in.

If any redrawn work on any of the plates of this subject has been called for, and has not yet been completed, it should be satisfactorily finished at this time. Having completed all required work on the plates of this subject, the work of the next subject should be taken up at once.

A CATALOG OF SELECTED DOVER
BOOKS IN ALL FIELDS OF INTEREST

CONCERNING THE SPIRITUAL IN ART, Wassily Kandinsky. Pioneering work by father of abstract art. Thoughts on color theory, nature of art. Analysis of earlier masters. 12 illustrations. 80pp. of text. 5⅜ x 8½. 0-486-23411-8

CELTIC ART: The Methods of Construction, George Bain. Simple geometric techniques for making Celtic interlacements, spirals, Kells-type initials, animals, humans, etc. Over 500 illustrations. 160pp. 9 x 12. (Available in U.S. only.) 0-486-22923-8

AN ATLAS OF ANATOMY FOR ARTISTS, Fritz Schider. Most thorough reference work on art anatomy in the world. Hundreds of illustrations, including selections from works by Vesalius, Leonardo, Goya, Ingres, Michelangelo, others. 593 illustrations. 192pp. 7⅛ x 10¼. 0-486-20241-0

CELTIC HAND STROKE-BY-STROKE (Irish Half-Uncial from "The Book of Kells"): An Arthur Baker Calligraphy Manual, Arthur Baker. Complete guide to creating each letter of the alphabet in distinctive Celtic manner. Covers hand position, strokes, pens, inks, paper, more. Illustrated. 48pp. 8¼ x 11. 0-486-24336-2

EASY ORIGAMI, John Montroll. Charming collection of 32 projects (hat, cup, pelican, piano, swan, many more) specially designed for the novice origami hobbyist. Clearly illustrated easy-to-follow instructions insure that even beginning papercrafters will achieve successful results. 48pp. 8¼ x 11. 0-486-27298-2

BLOOMINGDALE'S ILLUSTRATED 1886 CATALOG: Fashions, Dry Goods and Housewares, Bloomingdale Brothers. Famed merchants' extremely rare catalog depicting about 1,700 products: clothing, housewares, firearms, dry goods, jewelry, more. Invaluable for dating, identifying vintage items. Also, copyright-free graphics for artists, designers. Co-published with Henry Ford Museum & Greenfield Village. 160pp. 8¼ x 11. 0-486-25780-0

THE ART OF WORLDLY WISDOM, Baltasar Gracian. "Think with the few and speak with the many," "Friends are a second existence," and "Be able to forget" are among this 1637 volume's 300 pithy maxims. A perfect source of mental and spiritual refreshment, it can be opened at random and appreciated either in brief or at length. 128pp. 5⅜ x 8½. 0-486-44034-6

JOHNSON'S DICTIONARY: A Modern Selection, Samuel Johnson (E. L. McAdam and George Milne, eds.). This modern version reduces the original 1755 edition's 2,300 pages of definitions and literary examples to a more manageable length, retaining the verbal pleasure and historical curiosity of the original. 480pp. 5⁵⁄₁₆ x 8¼. 0-486-44089-3

ADVENTURES OF HUCKLEBERRY FINN, Mark Twain, Illustrated by E. W. Kemble. A work of eternal richness and complexity, a source of ongoing critical debate, and a literary landmark, Twain's 1885 masterpiece about a barefoot boy's journey of self-discovery has enthralled readers around the world. This handsome clothbound reproduction of the first edition features all 174 of the original black-and-white illustrations. 368pp. 5⅜ x 8½. 0-486-44322-1

STICKLEY CRAFTSMAN FURNITURE CATALOGS, Gustav Stickley and L. & J. G. Stickley. Beautiful, functional furniture in two authentic catalogs from 1910. 594 illustrations, including 277 photos, show settles, rockers, armchairs, reclining chairs, bookcases, desks, tables. 183pp. 6½ x 9¼. 0-486-23838-5

AMERICAN LOCOMOTIVES IN HISTORIC PHOTOGRAPHS: 1858 to 1949, Ron Ziel (ed.). A rare collection of 126 meticulously detailed official photographs, called "builder portraits," of American locomotives that majestically chronicle the rise of steam locomotive power in America. Introduction. Detailed captions. xi+ 129pp. 9 x 12. 0-486-27393-8

AMERICA'S LIGHTHOUSES: An Illustrated History, Francis Ross Holland, Jr. Delightfully written, profusely illustrated fact-filled survey of over 200 American lighthouses since 1716. History, anecdotes, technological advances, more. 240pp. 8 x 10¾. 0-486-25576-X

TOWARDS A NEW ARCHITECTURE, Le Corbusier. Pioneering manifesto by founder of "International School." Technical and aesthetic theories, views of industry, economics, relation of form to function, "mass-production split" and much more. Profusely illustrated. 320pp. 6⅛ x 9¼. (Available in U.S. only.) 0-486-25023-7

HOW THE OTHER HALF LIVES, Jacob Riis. Famous journalistic record, exposing poverty and degradation of New York slums around 1900, by major social reformer. 100 striking and influential photographs. 233pp. 10 x 7⅞. 0-486-22012-5

FRUIT KEY AND TWIG KEY TO TREES AND SHRUBS, William M. Harlow. One of the handiest and most widely used identification aids. Fruit key covers 120 deciduous and evergreen species; twig key 160 deciduous species. Easily used. Over 300 photographs. 126pp. 5⅜ x 8½. 0-486-20511-8

COMMON BIRD SONGS, Dr. Donald J. Borror. Songs of 60 most common U.S. birds: robins, sparrows, cardinals, bluejays, finches, more–arranged in order of increasing complexity. Up to 9 variations of songs of each species.
Cassette and manual 0-486-99911-4

ORCHIDS AS HOUSE PLANTS, Rebecca Tyson Northen. Grow cattleyas and many other kinds of orchids–in a window, in a case, or under artificial light. 63 illustrations. 148pp. 5⅜ x 8½. 0-486-23261-1

MONSTER MAZES, Dave Phillips. Masterful mazes at four levels of difficulty. Avoid deadly perils and evil creatures to find magical treasures. Solutions for all 32 exciting illustrated puzzles. 48pp. 8¼ x 11. 0-486-26005-4

MOZART'S DON GIOVANNI (DOVER OPERA LIBRETTO SERIES), Wolfgang Amadeus Mozart. Introduced and translated by Ellen H. Bleiler. Standard Italian libretto, with complete English translation. Convenient and thoroughly portable– an ideal companion for reading along with a recording or the performance itself. Introduction. List of characters. Plot summary. 121pp. 5¼ x 8½. 0-486-24944-1

FRANK LLOYD WRIGHT'S DANA HOUSE, Donald Hoffmann. Pictorial essay of residential masterpiece with over 160 interior and exterior photos, plans, elevations, sketches and studies. 128pp. 9¼ x 10¾. 0-486-29120-0

CATALOG OF DOVER BOOKS

LIGHT AND SHADE: A Classic Approach to Three-Dimensional Drawing, Mrs. Mary P. Merrifield. Handy reference clearly demonstrates principles of light and shade by revealing effects of common daylight, sunshine, and candle or artificial light on geometrical solids. 13 plates. 64pp. 5⅜ x 8½. 0-486-44143-1

ASTROLOGY AND ASTRONOMY: A Pictorial Archive of Signs and Symbols, Ernst and Johanna Lehner. Treasure trove of stories, lore, and myth, accompanied by more than 300 rare illustrations of planets, the Milky Way, signs of the zodiac, comets, meteors, and other astronomical phenomena. 192pp. 8⅜ x 11.

0-486-43981-X

JEWELRY MAKING: Techniques for Metal, Tim McCreight. Easy-to-follow instructions and carefully executed illustrations describe tools and techniques, use of gems and enamels, wire inlay, casting, and other topics. 72 line illustrations and diagrams. 176pp. 8¼ x 10⅞. 0-486-44043-5

MAKING BIRDHOUSES: Easy and Advanced Projects, Gladstone Califf. Easy-to-follow instructions include diagrams for everything from a one-room house for bluebirds to a forty-two-room structure for purple martins. 56 plates; 4 figures. 80pp. 8⅜ x 6⅞. 0-486-44183-0

LITTLE BOOK OF LOG CABINS: How to Build and Furnish Them, William S. Wicks. Handy how-to manual, with instructions and illustrations for building cabins in the Adirondack style, fireplaces, stairways, furniture, beamed ceilings, and more. 102 line drawings. 96pp. 8¾ x 6⅜. 0-486-44259-4

THE SEASONS OF AMERICA PAST, Eric Sloane. From "sugaring time" and strawberry picking to Indian summer and fall harvest, a whole year's activities described in charming prose and enhanced with 79 of the author's own illustrations. 160pp. 8¼ x 11. 0-486-44220-9

THE METROPOLIS OF TOMORROW, Hugh Ferriss. Generous, prophetic vision of the metropolis of the future, as perceived in 1929. Powerful illustrations of towering structures, wide avenues, and rooftop parks—all features in many of today's modern cities. 59 illustrations. 144pp. 8¼ x 11. 0-486-43727-2

THE PATH TO ROME, Hilaire Belloc. This 1902 memoir abounds in lively vignettes from a vanished time, recounting a pilgrimage on foot across the Alps and Apennines in order to "see all Europe which the Christian Faith has saved." 77 of the author's original line drawings complement his sparkling prose. 272pp. 5⅜ x 8½.

0-486-44001-X

THE HISTORY OF RASSELAS: Prince of Abissinia, Samuel Johnson. Distinguished English writer attacks eighteenth-century optimism and man's unrealistic estimates of what life has to offer. 112pp. 5⅜ x 8½. 0-486-44094-X

A VOYAGE TO ARCTURUS, David Lindsay. A brilliant flight of pure fancy, where wild creatures crowd the fantastic landscape and demented torturers dominate victims with their bizarre mental powers. 272pp. 5⅜ x 8½. 0-486-44198-9

Paperbound unless otherwise indicated. Available at your book dealer, online at **www.doverpublications.com**, or by writing to Dept. GI, Dover Publications, Inc., 31 East 2nd Street, Mineola, NY 11501. For current price information or for free catalogs (please indicate field of interest), write to Dover Publications or log on to **www.doverpublications.com** and see every Dover book in print. Dover publishes more than 500 books each year on science, elementary and advanced mathematics, biology, music, art, literary history, social sciences, and other areas.